DRAWING NOW

BERNICE ROSE

THE MUSEUM OF MODERN ART

NEW YORK

THIS BOOK AND THE EXHIBITION IT ACCOMPANIES HAVE BEEN MADE POSSIBLE THROUGH THE GENEROUS SUPPORT OF THE NATIONAL ENDOWMENT FOR THE ARTS IN WASHINGTON, D.C., A FEDERAL AGENCY. THE EXHIBITION WILL TRAVEL ABROAD UNDER THE AUSPICES OF THE INTERNATIONAL COUNCIL OF THE MUSEUM OF MODERN ART, NEW YORK.

LIST OF ILLUSTRATIONS

THE ILLUSTRATIONS ARE ACCOMPANIED BY A BIO-GRAPHICAL AND BIBLIOGRAPHICAL NOTE FOR EACH ARTIST. ALL WORKS ARE ON PAPER UNLESS ANOTHER SUPPORT IS INDICATED. THE DIMEN-SIONS OF ILLUSTRATED WORKS ARE INDICATED IN THE CAPTIONS AND ARE GIVEN BOTH IN INCHES AND IN CENTIMETERS, HEIGHT PRECEDING WIDTH. DEPTH IS INCLUDED FOR THREE-DIMENSIONAL WORKS. SHEET SIZES ARE SPECIFIED FOR WORKS ON PAPER.

ACKNOWLEDGMENTS

I wish to express my gratitude for the kind cooperation and assistance I have received from many people and many institutions in the preparation of this publication and its accompanying exhibition—both of which, like many other projects in the Museum's program, would not have been possible at all without the support of the National Endowment for the Arts.

For generous help in Europe I wish to thank Jürgen Harten, Director of the Kunsthalle, Düsseldorf; Carlo Huber, Director of the Kunsthalle, Basel; and Dieter Koepplin, Curator of Prints and Drawings at the Kunstmuseum, Basel.

At The Museum of Modern Art, I am particularly indebted to colleagues who have given unsparingly of their time and energy. Richard Palmer and Lisa Messinger have worked with untiring thoroughness on all phases of the project. Mr. Palmer has been unstinting in his support, and his creative approach to solving problems has been invaluable. Mrs. Messinger made an important contribution to this publication, researching and writing the biographic and bibliographic notes. Others have contributed valued advice, Mary Lea Bandy and Riva Castleman in particular. I am also grateful to Elisa Ian and Monawee Richards for their indispensable help. Special thanks are due William S. Lieberman, Director of the Department of Drawings, for his continuous support of this project since its inception some three years ago. His professional standards have been a measure and a guide throughout.

In addition, two friends provided help at critical moments—Harriet Bee, especially with editorial advice, and Anne Rogin.

In the Museum's Department of Publications, Francis Kloeppel and Jane Fluegel have guided this publication through under difficult circumstances. Carl Laanes, who designed this volume, and Jack Doenias, who oversaw its production, have worked against a compressed schedule that imposed severe difficulties.

My most important debt is to the artists themselves. Without their collaboration neither the publication nor the exhibition would have been possible.

—B.R.

DRAWING NOW

ROBERT RAUSCHENBERG. *ERASED DE KOONING.*
1953. ERASED PENCIL, 19 X 14 1/2" (48.3 X 36.9 CM).
COLLECTION OF THE ARTIST

GIVEN the radical history of modernist art, drawing has until recently been regarded as a conservative medium, resistant to ideas of innovation or extension. As a discipline it has with few exceptions remained within parameters basically defined by the end of the seventeenth century. Perhaps the most notable innovation in drawing of the three intervening centuries was the introduction of collage into fine art by Braque and Picasso in the second decade of this century. However, during the past twenty years a number of artists have, and with increasing intensity since the middle sixties, seriously investigated the nature of drawing, investing major energies in a fundamental reevaluation of the medium, its disciplines, and its uses. With this process of reevaluation and renewal, drawing has moved from one context, that of a "minor" support medium, an adjunct to painting and sculpture, to another, that of a major and independent medium with distinctive expressive possibilities altogether its own. At the same time drawing has relinquished none of its traditional functions, and has kept its traditional resources as constant points of reference for reinvestigation. Most recently, contemporary drawing has returned to classical roots of drawing as a means of rethinking its prerogatives.

From the fourteenth century on, speculation on drawing both as an independent medium and in relation to sculpture and painting occupied the attention of numerous artist-theoreticians. By the sixteenth century drawing had been equated with "invention," with the engendering of the "idea" or form of things. Giorgio Vasari, the artist-biographer, described drawing as originating in the intellect of the artist, its first concrete realization being the sketch. In 1607, Federico Zuccari, crowning three centuries of speculation, elevated drawing to a metaphysical activity with its origin in the mind of God. A Mannerist painter and founder of the Academy of St. Luke in Rome, Zuccari was the first in a long line of academicians extending directly to the French Academy of the nineteenth century; his major contribution to art theory, *Idea of the Sculptors, Painters, and Architects,* as explained by Erwin Panofsky[2] was an investigation of how an artistic representation is possible at all: "Like a good High-Scholastic Aristotelian...[Zuccari] proceeds from the premise that that which is to be revealed in a work of art must first be present in the mind of the artist." Zuccari equates *disegno* (a term that embraces both design and drawing) with the ancient conception of "idea." To *disegno* he accords a dual role, distinguishing between *disegno interno* and *disegno externo.* The "inner design" (or "idea") which precedes execution and actually is completely independent of it can by engendered by man in his mind only because of God; man's idea is only a spark of the divine mind. *Disegno externo* is the external, visual shape of the structured concept, the actual artistic representation, be it pictorial, plastic, or architectural. Thus to *disegno* Zuccari accords the generating power of artistic representation: since "the human intellect, by virtue of its participation in God's ideational ability and its similarity to the divine mind as such, can produce in itself the *forme spirituali* of all created things and transform these *forme* to matter, there exists, as if by divine predestination, a necessary coincidence between man's procedures in producing a work of art and nature's procedures in producing reality—a predestination which permits the artist to be certain of an objective correspondence between his products and those of nature."

As Lawrence Alloway points out, this is one notion of drawing: "the artist at his most rigorously intellectual. In this sense drawing is the projection of the artist's intelligence in its least discursive form."[3] There is another, drawing as an autographic (indeed biographical) revelation, presenting the artist's first and most intimate and confessional marks. This latter sense is not recent. Throughout the Renaissance, drawing was understood in a range from "invention"—as the first idea and intellectual plan of work—to "drawing as graphological disclosure."[4]

For the Renaissance, drawing was both a poetic and scientific discipline with the highest intellectual credentials. Without drawing it was impossible to

describe the newly emergent disciplines of anatomy, geometry, and perspective, which were considered basic to a scientifically accurate grasp of objects as seen in nature or as conceived in the imagination. Drawing was an integral part of Leonardo's exploration of both forms and causes.

In central Italy in the High Renaissance, painters and sculptors were first and foremost draftsmen. Line—the heart of art—was held to be superior to color in the generation and ordering of imagery. Line was the governing principle, circumscribing color and determining the contours of all objects with the tactilely illusionistic, fictive space of the Renaissance window of reality. Perspective was linear projection, a conceptual abstract; delineation—the drawing of contours—was also understood to be a symbolic abstraction. Line, Leonardo asserted, does not occur in nature; in reality, the notion of line is intellectual, a prime conceptualization, which in itself describes nothing.

But line, if it was symbolic abstraction, was physically generated by an individual. As drawing departed from its craft traditions, skill was admired as facilitating individuality. Personal touch distinguished one artist from another and established hierarchies according to the quality of the "handwriting." According to one Renaissance master, "there is not need of more, no more time nor proof nor examination in the eyes of those who understand the matter and know that by a single straight line Apelles could be distinguished from that other immortal Greek painter, Protogenes."[5] A single drawing is thus descriptive of a whole stylistic language, synthesizing all of the elements necessary to recognize the artistic personality. Spontaneity was valued, but even those drawings which displayed intellectual detachment were appreciated as indicative of private thoughts, painstakingly revealed.

Drawing was intimate in use, intimate in scale (monumental drawings for murals were always covered by the painting process); its subjectivity was regarded as spiritual. Not until the mid-eighteenth century were drawings framed, glazed, and hung on walls. By that time intellectual speculation about the nature of drawing had ceased, connoisseurship had replaced speculation, and drawing was fixed in the forms handed down to us by tradition.

The tradition had been fixed in the seventeenth century, and until the advent of Conceptual art in the 1960s the two senses of drawing, the conceptual and the autographic, had not been rigorously distinguished. However, as the first artistic representation—in terms of *disegno externo*—drawing had continued to be accepted as conceptual in its essence. The marks of a drawing have only a symbolic relationship with experience; it is not only that line does not exist in nature, but the whole relational construct of a drawing is a conceptual proposition by the artist—even when it is of a natural phenomenon— to be completed by the spectator through an act of ideation.

AT this point, the outlines of the tradition we have inherited should perhaps be clarified. In its most general sense, drawing is simply marking on a background surface with any implement to create an image. As such it is fundamental to all the visual arts, but in Western art drawing is usually discussed in terms of a split between the idea and the execution of a finished work. Drawing has thus come to be associated with particular techniques and modes of expression, even particular tools and mediums, although these have been considerably expanded in the twentieth century.

The first, and simplest, mode of drawing is delineation, which is the use of line in its purest form and is usually associated with contour drawing. In contour drawing the different aspects of an object have been reduced to an ideal image unmodulated by effects of light and shadow. The line of the contour may be continuous or broken. In most drawings, line is in fact deliberately broken to provoke kinetic responses in the viewer corresponding to the movements of the act of drawing.

The second mode is form drawing, wherein effects of light and shadow have been added to the linear contour without regard to local tones. The effect is

that of relative illumination of the entire surface. The tones may be obtained by a variety of linear markings—cross-hatching, for instance—or by washing in shadows and highlights with a liquid medium and brush.

The third mode is color-value drawing, in which light and dark areas express the difference in local tones of the objects represented. The ambition of color-value drawing is to approach as closely as possible all of the effects of light and form normally expressed by colored rendering.

There are also drawings done in full color with colored lines. In addition, there are color drawings which would be difficult to distinguish from paintings; watercolors are generally considered a class of colored drawing.

Collage, which Matisse described as "drawing with scissors," is the cutting and pasting of papers to create either a part or the whole of an image.

The supports for drawing vary from culture to culture and age to age. Drawings have been done on the ground, on walls, on pottery, on stone tablets, and on woven grounds. Since the invention and wide distribution of cheap paper, they have been identified most strongly with the limited, intimate format defined by the four edges of a sheet of paper.

Tools may range from a simple stick scratching the ground to the metal points used for drawing on elaborately prepared grounds in the early Renaissance. More recent inventions for drawing have been the graphite pencil and the chalk stick. The brush and the pen are also traditional drawing tools.

Drawings are enormously varied, extending from the simple to the elaborate, from the extemporaneous to the deliberate and labored. They are usually divided into two groups: preparatory and finished.[6] The preparatory include all drawings leading up to a finished work in another medium—including the underdrawing of painting which is then glazed over or covered. Sculptors' drawings are usually presented as a special class of preparatory drawings, because they generally do not refer spatially to the four edges of the sheet of paper on which they are placed.

In the second group are drawings which are in themselves finished works. (Illustrations are a particular class of finished drawings.) Frequently a study may be so complete or so satisfying emotionally that to the modern aesthetic it too may function as a finished work. In fact, as modern aesthetics has come to accept fragmentation and reduction, many kinds of drawings previously classified as preliminary and unfinished have come to be regarded as complete. It is directly inferred in the traditional aesthetic of drawing that the incomplete can provide an initial, intuitive experience quite independent of the experience of the finished work. Tradition also maintains that any drawing is "artistically important when it documents an active moment of ideation quite independently of its formal aspects, which vary according to the shifting idioms of representation."[7]

JUST as drawing has inherited its traditions as a medium, in expanding its function to that of major, independent work it also inherits—or joins, as it were, its traditions to—the ongoing preoccupations of modern visual art.

The conceptualization of art has been the leitmotif of the century, along with "the absolutizing of the artist's state of mind or sensibility as prior to and above objects."[8] From Impressionism on, art and the mode of its expression have been identified. With time the attitude of artists grew more analytic. A statement by Cézanne affirms the part intelligence plays in the ordering of visual experience: "...art is personal perception. This perception I place in feeling and ask of intelligence that it organize it into a work."[9] Duchamp, who has been at the heart of the conceptualization of art, said as early as 1912 that idea had become his primary interest; he wished "to put painting once again at the service of the mind."[10]

Abstraction has gone hand in hand with extreme subjectivity. Already evident in Impressionism, the tendency to abstract, to relate all objects in terms of their interaction as lines and colors on a two-dimensional surface—however

emotive or high in visual incident and excitement the individual work may be—will readily be recognized as a conceptualization of experience, in which the objects are subjective rather than objective phenomena.

Impressionism was a reaction to the extreme vulgarization of representational art, which had become either passive picturing of the everyday or else the ideal picturing of a heroic, allegorical world. In reality, as the artist "holds the world in mind"[11] and renders representationally onto a two-dimensional surface, he employs conceptualization no less than in abstracting or reducing beforehand and using formally expressive devices directly, without benefit of representation or illusion.

A Renaissance painting is as much a conceptualization as is a Picasso or a Malevich. The artist's move toward abstraction came about in relation to the vulgarization of the objects of the world and in relation to their consumption by other mediums. The invention of photography created immense confusion in the popular mind as to what painting was about. Art loosened its ties to the representational rendering of the world when it felt representation had been vulgarized, had lost its power to convey those aspects of experience which had been proper to the art of painting. When the public confused the objectives of painting and photography, the painter's answer was to redefine his art in terms of those things which were proper to it—the two-dimensionality of the canvas surface, the material in relation to that surface, the process by which the material is applied, and the mark left by the process. Thenceforth any representation had to be seen in relation to the process by which it had been made, and as painting became increasingly identified with its own processes, it still further loosened its ties to the illusionistic space of representation, however abstract.

If conceptualization with reference to representation and to abstraction itself has been an ongoing concern of artists through the century, then concentration on the mark itself in drawing, and the use of drawing for itself alone—in relation to its definition as "ratiocination" (*disegno interno*)—are not illogical. Thus once again the dual tradition of drawing as conceptual and as graphological is confronted, though now radicalized by a series of intervening historical moves and new attitudes.

To establish an exact moment or single motivation for a change within any discipline is rarely possible. It is true that the immediate past plays a historically determinist part in the formation of recent art—Robert Rauschenberg's need to literally erase Willem de Kooning by erasing a de Kooning drawing (*Erased de Kooning,* 1953) does not erase Rauschenberg's debt to de Kooning. Nonetheless much recent art is eclectic and freely elective in its sources. Individual artists seek individual strategies even within generalized areas of agreement; each artist seeks to construct a new personal reality. Moreover, three or more generations of university-educated artists, aware of art theory and art history, as well as literature, philosophy, and the sciences, are free to make use of the entire history of ideas.

Nevertheless, it was the generation of Abstract Expressionists, just prior to Rauschenberg and Johns, which brought the issue of finish within a painting to a clear head and thus initiated a rethinking of the possibilities of drawing. If all the steps, all the struggle and thinking leading to the so-called finished work could be incorporated into that work, remaining a visible and vital part of its character—if a painting could be unfinished or "incomplete" in the sense that sketches are unfinished—then sketches and paintings could be afforded equal status and drawing could cease to function merely as a step along the way to painting. The personal struggle, the biographic markings of the sketch appear in the works of Pollock and de Kooning as the generating source and subject of the work itself. Both Pollock and de Kooning understood that drawing, freed from the limits of the preliminary, could generate independent works. In all of his mature work Pollock subverts line to make painting, but it is in his black-and-white canvases of 1951-52 that he blows the scale of drawing right up to the monumental. Drawing in dripped black paint

from one work to the next on a continuous strip of white canvas instead of a sketch pad, Pollock provides a series of drawings that rival paintings in their breadth of scale and ambition. They are revelatory—filled with the sense of a confession of secret life—and as totally finished as any painting. Adumbrations like Pollock's large black-and-white drawings are seldom seen as precedents before a later generation's accomplishments reveal them as such.

De Kooning, working from a coloristic, painterly tradition, subverts painting to make drawings (it was not until the mid-sixties that de Kooning, for the first time since his earliest Ingres-like drawing of the forties, began to make small charcoal drawings, using the soft black line coloristically in the tradition of Matisse). In his series of Women, paint and brush are used for drawing, of both large and small works. There is no distinction in the working method from large to small; all work is equally autographic and spontaneous in the immediacy of the marks—equally destructive of traditional ideas of finish. The sketch is elevated to a complete work. Even when a small work is a study for a larger one, the sketch is one action, the painting another.

It was, of course, Cézanne who had first raised in terms of modern concerns the issue of finish in painting. Cézanne equated drawing and painting, stroke and color, stating, "As one paints one draws: the more harmony there is in the colors the more precise the drawing becomes..."[12] But Henri Matisse was the twentieth century's master of the simplified contour line, the line in which gestural expression is reduced to an essence. From his earliest student years Matisse had sought to reduce the elements of form in a drawing to a single expressive contour line that would embrace not only form, but color as well. It is significant that the fundamental formal issue for these artists is contour. The ties between contour drawing and "imitation"—representation—have been hard to break; drawing has been the classical medium for the process of rationalization from representation to abstraction—van Doesburg's famous series of cows is a striking illustration of this process. But line in its pure state describes only itself. It is the relationship of one line to another that makes line function descriptively. As drawing moves away from description of contour it defines itself in terms of its primary unit, the nondescriptive line. For Cézanne, Pollock, and de Kooning, line operates always in the most tenuous and delicate balance between these two functions—and for a brief time it breaks free of contour in Pollock's paintings. In contemporary drawing, the generation of autonomous line, the use of nondescriptive lines as modular units, and the compression of gesture are all formal devices inherent in these prior uses of gesture and line.

If drawing is classically defined by movement in relation to linearism, then, as drawing moves toward tone and shadow, it moves toward coloristic devices—toward the imitation of painterly effect and painting itself. The ultimate dream of numerous draftsmen has been the black line which functions as color; two of the most extraordinary draftsmen of the modern era, Georges Seurat and Odilon Redon, used black in such a manner as to suggest all of the nuances of light and form normally accorded to color rendering. Seurat's velvety black, created by using the broad side of a Conté crayon in broad tonal areas on a rough paper, allows the residual white of the paper to show through. This technique builds massive forms while avoiding contour drawing—Seurat, in fact, avoids linear definition at the edges of his forms. For Seurat the issue of finish was directly opposite to the issue of finish in Pollock and de Kooning. Seurat's measure was the nineteenth-century painting, his ambition to make drawings equal in finish—and importance—to paintings. The large drawing of his friend Aman-Jean in the collection of The Metropolitan Museum of Art, New York, is "a manifesto of the independence of draftsmanship."[13] It was the first work by the artist in a public exhibition—the Salon des Indépendants of 1883—and it was exhibited unabashedly as a finished work. While the concept of the "finished" drawing goes back to Michelangelo's Presentation drawings, Seurat is the first modern artist to aspire to drawings as independent, finished works of art.

ROY LICHTENSTEIN. *STILL LIFE WITH SCULPTURE.* 1973. COLORED AND GRAPHITE PENCIL, 7 1/8 X 8 7/8" (18.4 X 22.7 CM). PRIVATE COLLECTION, NEW YORK

Thus, while it had been an aspiration in art for some time to produce finished independent drawings—and many such drawings have been created—it was not until drawing had transformed itself through its autographic function and was actually absorbed into a new aesthetic of "incompleted" painting, that drawing could cease to function primarily as a step toward painting and become an independent action, and that drawings could be made consistently as finished works—could function as an alternative major mode of expression.

The story of drawing from the mid-fifties onward is the story of a gradual disengagement of drawing as autography or graphological confession and an emotive cooling of the basic mark, the line itself. There is a gradual move away from drawing that is painterly, coloristic, and eclectically inclusive in its use of materials, a move toward more classical mediums and linear and tonal modes. At the same time there is a change in the relational structure of the drawing as an object. A drawing can be described as a structure in which lines and other kinds of marks are arranged in related groupings according to a master plan to which the whole arrangement is subordinate. In traditional drawing this arrangement is hierarchical—characterized by a broad range of expressive devices variously subordinated to one another as well as to the motif. In recent drawings expression is dependent on a reduced and simplified range of marks, rearranged so that their relationship to one another becomes contingent, and their relationship to the rectangle of the sheet or the space allocated is the primary regulating device. While in many drawings the limits of the format, as they modify the application of the system used to generate the work, determine the internal relationships of the marks, in others, conversely, the internal relationships of the system as it operates on the space determine the limits of the format. When line is used for contour drawing, whether representational or abstract, it too is less inflected and tends to be used inexpressively or, as in Lichtenstein's drawings, almost as a stereotype.

Attention thus focuses to a greater degree on the line itself; marks are broadly grouped, and the groups tend to be repeated almost serially. As a direct result of this kind of restructuring and progressive isolation of its "bones," drawing becomes less a matter of spontaneity and is more deductive, conceptual, both in approach and execution. The mark itself and the process by which it is generated come to be more and more the subject of drawing. As this happens the graphological and conceptual functions of drawing merge.

Recent attempts have been made to evolve a system for describing drawings according to the model of linguistic analysis supplied by modern anthropology. According to this system, the marks of the drawing correspond to the basic units of verbal speech, their relationship is analogous to that described by grammar and syntax, and their meaning is a function of their uses in larger syntactical structures. This is a model based on traditional drawing—drawing, moreover, with a representational subject. It assumes that a work of art is susceptible to analysis as a structure following the pattern of language. Art, however, is a structure of its own; its relation to language is best expressed by Merleau-Ponty's observation that Cézanne is in the position of the man who spoke the first word. Language is a linear structure, vision is holistic. The direction of art since the forties has been to insist more and more on the "wholeness" of the work of art, to insist on the work of art as a field. Within the period under discussion, it is not simply that the mark becomes less inflected and more exposed to vision as just what it is, but the scale on which drawing is made also changes. The drawing is seen as a field coextensive with real space, no longer subject to the illusion of an object marked off from the rest of the world. The space of illusionism changes, merges with the space of the world, but by doing so it loses its objective, conventional character and becomes subjective, accessible only to the individual's raw perception.

It would be inaccurate to say that this is a description of all drawing done in the last twenty years. It applies, however, to the drawing that is most insistent on its own logic as a medium and is the most convincing, emotionally and intellectually.

JOSEPH BEUYS. *COLORED PICTURE.* 1958. HARE'S BLOOD ON CLOTH, 9 5/8 X 8 1/2" (24.5 X 21.5 CM). KUNSTMUSEUM, BASEL

JOSEPH BEUYS was born in 1921 in Krefeld, Germany. In 1940 Beuys became a wartime pilot on the Russian front and later survived a severe plane crash. In 1947 he became a student of sculpture at the Düsseldorf Academy, studying with Ewald Mataré until 1951. From 1951 to 1961 Beuys lived in isolation in the Lower Rhineland. He was recalled to Düsseldorf in 1961 to succeed Mataré as professor of sculpture at the Academy and subsequently became one of the most popular art teachers in Germany. Beuys staged several events that were Dada in nature and eventually created the first "happenings" and environments in Germany during the 1960s. From the late '60s on Beuys became increasingly involved with teaching and politicizing and in 1972 was dismissed from his teaching post after demonstrating for educational reforms. He exhibited widely in Europe, but it was not until 1972 that his work was exhibited in the U.S. at the Harcus-Krakow Gallery, Boston. In 1974, Beuys circulated in England a group of drawings summarizing his artistic preoccupations over the years.

Bibliography:

Adriani, Götz; Konnertz, Winfried; and Thomas, Karin. *Joseph Beuys.* Cologne: M. DuMont Schauberg, 1973.

Grinten, Franz Joseph van der, and Grinten, Hans van der. *Joseph Beuys: Bleistiftzeichnungen aus den Jahren 1946-1964.* Berlin: Propyläen Verlag, 1973.

Jappe, Georg. "A Joseph Beuys Primer," *Studio International,* September 1971, pp. 65-69.

Joseph Beuys: The Secret Block for a Secret Person in Ireland. Catalog. Oxford: Museum of Modern Art, 1974.

Lieberknecht, Hagen. *Joseph Beuys: Zeichnungen 1947-59 I.* Cologne: Schirmer Verlag, 1972.

Meyer, Franz. *Joseph Beuys.* Catalog. Basel: Kunstmuseum, 1969.

Wember, Paul. *Joseph Beuys: Zeichnungen 1946-1971.* Catalog. Krefeld: Museum Haus Lange, 1974.

THIS essay is structured around an exhibition prepared for The Museum of Modern Art in January of 1976. Many artists, many works were included in the exhibition; it is possible here to discuss only a few in detail. Concentrating on their specific relationship to the ongoing reexamination of drawing in terms of its own function and in relation to the main concerns of modernism, the discussion begins with those artists whose work is most graphological, coloristic, and painterly and ends with those whose concerns are more conceptual.

Two innovations had been at the core of the art of the late forties and the fifties. Both were graphic in origin. The first of these was Surrealist automatic drawing, which was based on the principle of drawing as graphological disclosure, on the vitality of the moving hand. Here, however, the objective was to draw without conscious control, to introduce pure chance and "the unreasonable order" of dream images into the making of art. As a technique automatic drawing produces a scrawling, random linear configuration antithetical to the idea of structured, hierarchical relationships. It tends toward abstraction rather than description. The second of these innovations is the "collage aesthetic."[14] Invented by Max Ernst, it has its origin in traditional Cubist collage, but in Ernst's hands collage became visionary: the juxtaposition of unrelated images, by whatever means possible, for the creation of a hallucinatory image.

The first of these inventions is the basis on which the drawing of Joseph Beuys and Cy Twombly is founded—although for Twombly at one remove, through Abstract Expressionism. For Rauschenberg the second plays an important part in the maturation of his imagery.

Ideally the artist while drawing automatically is in a state of trance or reproduces a set of circumstances which distance the ordinary and free his more fundamental impulses. Skill is not a consideration. Beuys, while allied to the tradition of automatic drawing, stands alone in his choice of sources and techniques. Instead of resorting to the inchoate individual unconscious, he assumes the role of one to whom the unconscious drive of numerous civilizations has assigned the function of primary executor of fantasies; he assumes the role of shaman. Anthropologists see the shaman as an individual with "a vocation for ecstasy." It is the shaman's role to mediate between the forces of the world and the fantastic forces of the unknown, in order to perpetuate the life forces of the community. According to anthropologists the initial impulse to art is to be found in the shaman's act of ecstatic mediation. In his ceremonial function he creates images meant to insure the beneficent behavior of the spirit world and the world of natural forces. Such ceremonies are to be seen as the origin of the first wall drawings in caves.

Drawing for Beuys is a process of opening thought beyond the habitual patterns imposed by speech; it gives form to what is impossible to say—for Beuys believes that to think is to create form. As he conceives it, form is in a constant metamorphic passage between one state and another, and drawings are the means he uses to convey the sense of passage, "the feeling that something must emerge from the material just as wind, water, clouds, and smoke are in constant transition."[15] Drawing channels the chaotic energy of these invisible forces "through action to organized form. The hand and mind that guide the pencil...must be in tune with the forces being expressed."[16] His drawing is the physical weaving of an energy field; his line is a "conductor."

Beuys's drawings assume a social role, organizing the fantasies and collective memory of whole civilizations as they are expressed in legends. His early drawings convey the sense of transition through imagery—metamorphic figures of humans and animals as described in legends. Later drawings are more material and painterly, the state of transition being expressed through the use of ephemeral materials, the legendary themes through signs. A frequent sign is a cross—a combination of the Christian cross and a stag's foot. Frequently the sign will be scratched into the painterly surface as a shaman might scratch an image into the ground with a stick. A favorite medium is hare's blood, a sign of alchemical transformation and chemical change.

JOSEPH BEUYS. *STAG-FOOT CROSS 2X.* 1960. OIL, 15 3/4 X 20 1/8" (40 X 51 CM). KUNSTMUSEUM, BASEL

Beuys is a sculptor, trained originally as a natural scientist. He carries both as legacy and as burden the tradition of Western European art, especially that of German Expressionism and its deliberate primitivizing strain. His most specific debt in sculpture is to Kurt Schwitters. Yet his career is a process of movement away from the Expressionist tradition toward more conceptual concerns. Beuys is one of the first assemblagists to expand his métier to "happenings"; he frees himself to go in new directions by the enactment of his fantasies in the role of shaman. Drawing is fundamental to this enactment; as he opens art to new possibilities and new materials, he uses drawing as the preparatory ground for all subsequent work. The drawings pass over into collages, collage-objects, and small paintings. They function also as records of works and as certificates of his presence. He draws everywhere, even diagramming ideas on table tops. Although his earliest drawings are banal, slightly later work is electrified by his compulsive scrawling. From about 1965 on he assumes control over a full range of twentieth-century techniques, but he is never, by design, an inventor of elegant linear relationships. More recent drawings, created on blackboards as parts of performances, have become obsessional diagrammatic notations of ideas for those performances. This is drawing itself (as a means of transmitting ideas) transformed into action, drawing as an act that insures freedom.[17] Beuys stands as the culmination of a tradition as he moves away from drawing as private disclosure to a more public idea of the role of draftsmanship.

The tension between painting and drawing is the continuing theme of Cy Twombly's work. His art is based on drawing as the generating source of the work of art. He is a painter whose imagery is consistently founded on the notion of calligraphy, on the physical act of handwriting. Paint is the ground in Twombly's work; the accidental tactile marks in the paint skin become the pretext for marking the surface as a schoolboy might scrawl on the wall.

Twombly's style too is based ultimately in automatic drawing, in that place in drawing inhabited by Arshile Gorky. Twombly's mark retains a vestigial metaphor—a vestigial sign which as it struggles to emerge from Twombly's scrawl seems also to struggle in some way to reach verbalization. Robert Pincus-Witten noted, "Drawing is the means par excellence by which ideas are made manifest. Yet Twombly, always aware that his art is not one of idea but of visual effect, came to resent the very means by which his art exposes him. His art is not about ideas, but mindlessness. Therefore what Twombly engenders is not drawing but the drawing away of drawing. It is a kind of hand-hating drawing, one which denies rather than affirms."[18] Pincus-Witten then goes on to note that because Twombly's latest "schemata"—for one cannot call Twombly's markings subjects—include geometric figures, numbers, cribbings from Leonardo's notebooks and studies, etc., his paintings come, ironically, despite his allegiance to "expressionist" aesthetics, to be germane to the conceptual. But it is precisely Twombly's hand-hating drawing, his distancing of the mark, his characteristic "rhetorical scale," the allusions to the metaphor of the wall as his space, created by his extremely elegant graphology—and in fact his effort to evade his own skill—which place him in a key position of conceptualization.

Twombly's historical position left him with the heritage of emotionalism inherent in the drawing of Abstract Expressionism. Twombly was both attracted by and skeptical of the confessional aspect of expression. In an effort to divest himself of that baggage he resorted to the idea of a more distanced mark. Working in a casually aloof style, yet distrustful of his own elegance, he tries always to retain the elements of scrawl. He has utilized handwriting drills and the chance markings of graffiti; he refuses to commit himself to taste. For Twombly, as for Beuys, Klee is pertinent to the stylization of the mark. His art is about style and about how the thing is made. His response to material, to his own mark is tactile and sensuous, but he wrenches the mark of drawing away from expressionism, cools it, and distances it—and focuses on its peculiar power of self-generation.

CY TWOMBLY. UNTITLED. NEW YORK, 1953. HOUSE PAINT AND PENCIL ON CANVAS, 28 X 45" (71.1 X 114.3 CM). COLLECTION HAROLD M. FONDREN, NEW YORK

CY TWOMBLY. UNTITLED. 1956. PENCIL, 22 X 30" (55.7 X 76.4 CM). COLLECTION OF THE ARTIST

CY TWOMBLY was born in 1929 in Lexington, Va. He studied at Washington and Lee University, Lexington, the Boston Museum School (1948–49), and the Art Students League, New York (1951). On Robert Rauschenberg's advice, Twombly spent two summers and a winter at Black Mountain College, N.C., where he met Robert Motherwell, Franz Kline, and Ben Shahn. In the early 1950s he served in the U.S. Army, deciphering codes. During his service he remained in New York State, maintaining his associations with New York artists. After being discharged, Twombly was granted a Virginia Museum of Fine Arts fellowship to travel through Europe; he visited Italy and North Africa with Robert Rauschenberg. His first one-man show was held at the Kootz Gallery, New York, in 1951. Since 1957 Twombly has lived and worked in Rome. His drawings and paintings have been shown in numerous museum and gallery exhibitions in Europe and the U.S. In 1975 he had a one-man exhibition at the Institute of Contemporary Art in Philadelphia.

Bibliography:

Bastian, Heiner. *Cy Twombly: Zeichnungen 1953-1973.* Berlin: Propyläen Verlag, 1973.
Bastian, Heiner, and Delehanty, Suzanne. *Cy Twombly: Paintings, Drawings, Constructions 1951-1974.* Catalog. Philadelphia: Institute of Contemporary Art, 1975.
Cy Twombly: Paintings and Drawings. Catalog. Milwaukee Art Center, 1968.
Dorfles, Gillo. "Written Images of Cy Twombly," *Metro,* June 1962, pp. 63-71.
Huber, Carlo. *Cy Twombly: Bilder 1953-1972.* Catalog. Bern: Kunsthalle, 1973.
Motte, Manfred de la. "Cy Twombly," *Art International,* June 1965, pp. 32-35.
Motte, Manfred de la. "Cy Twombly," *Quadrum,* 1964, pp. 35-46, 176-77, 180-81.
Pincus-Witten, Robert. "Cy Twombly," *Artforum,* April 1974, pp. 60-64.

CY TWOMBLY. UNTITLED. SPERLONGA, 1959. OIL, COLORED CRAYON, AND COLORED AND GRAPHITE PENCIL, 27 1/2 X 39 1/4" (70 X 99.6 CM). COLLECTION DR. REINER SPECK, COLOGNE

CY TWOMBLY. UNTITLED. NEW YORK, 1968. OIL
AND CRAYON, 30 X 40" (76.2 X 101.6 CM). COLLEC-
TION MR. AND MRS. VICTOR W. GANZ, NEW YORK

Robert Rauschenberg, who had been to Black Mountain College, North Carolina, in the late forties, persuaded Cy Twombly to go there in 1951; Rauschenberg himself went back in the summer of 1952 to present a mixed-media event, perhaps the first "happening" in the United States, along with composer John Cage, dancer Merce Cunningham, pianist David Tudor, and poet Charles Olson, who was then rector of the college. Literary sources, which had been anathema to one generation, became stimuli for the next, opening up possibilities of a new kind of image, as in Olson's own work:

> I turned to the young man on my right and asked, "How is it,
> there?" And he begged me protestingly don't ask, we are poor
> poor. And the whole room was suddenly posters and
> presentations
> of brake linings and other automotive accessories, cardboard
> displays, the dead roaming from one to another
> as bored back in life as they are in hell, poor and doomed
> to mere equipments...[19]

And so the unaesthetic object was introduced into poetry—"radial tires, lunar modules, combination locks, plastic bottles, disposable lighters"—the machine's junk, the detritus of a civilization. Schwitters had introduced pieces of junk into art, but never whole manufactured articles; de Kooning had quoted the torn-up environment of the city, but had not incorporated the junk of the city into the painting. At Black Mountain the freedom of experimentation made it all available, usable as one's own. And Olson, too, proposed the idea of the "field," the opening up of the composition, "or what can also be called composition by field, as opposed to inherited line, stanza, over-all form."[20]

For Robert Rauschenberg (and for Jasper Johns, indirectly), there was sufficient material here for a new style, a style which absorbs parts of the world, as many parts as possible—a visual style informed by poetry, random musical composition, impelled by the static sounds of the environment, by its disorganized impressions registered across a wall, registered as a series of transferred impressions and objects across the canvas field.

The scale of Robert Rauschenberg's paintings is large—literal-size to monumental. The scale of his drawings for Dante's Inferno is unusually small for him, but the conception of thirty-four drawings as a coherent closed series, interpreting the poet passage by passage with the images of the contemporary world, is monumental in scope, and cinematic in its conception of the frame-by-frame unfolding of the narrative. Also, the series (worked on for eighteen months) was a means of release from the pressure of a single masterwork.

A sensibility habituated to contingency does not relate to the world as an hierarchically ordered structure—contemporary experience is contingent, our lives ongoing and filled with incident, episodic. The question arises of how to organize the episodic into a coherent work of art. Rauschenberg has said of the kind of work which includes the Dante series: "But everyday, by doing consistently what you do with the attitude you have, if you have strong feelings, these things are expressed over a period of time as opposed to, say, one Guernica."[21] (In Twombly's work, where contingency is a felt quality—underground, felt in the threatened dissolution of the marks as they spread across space—the idea of series is nascent; in Rauschenberg it is explicit.)

The series was not intended, when Rauschenberg began, as the illustration for a book. Rather the illustrations were a means of evolving a new idea. With the Dante series Rauschenberg invents a "narrative" image which works in contemporary terms, and which he uses from that time forward. Dante's poem was a perfect incentive for working out such a problem. The poem is episodic, filled with chance meetings, held together by the voice of the narrator and the presence of three main figures, Dante, Virgil, and Beatrice.

Rauschenberg began the Dante series early in 1959 (like Dante when he began the Divine Comedy, Rauschenberg was thirty-five years old). He followed the sequence of the epic canto by canto, adhering strictly to the text, each drawing corresponding to one canto, until the thirty-four drawings were finished. He was

ROBERT RAUSCHENBERG. *THIRTY-FOUR DRAWINGS FOR DANTE'S "INFERNO": CANTO XII.* 1959-60. WATERCOLOR, WASH, RED AND GRAPHITE PENCIL, GOUACHE, BLACK CHALK, AND TRANSFER, 14 1/2 X 11 1/2" (36.8 X 29.2 CM). THE MUSEUM OF MODERN ART, NEW YORK, GIVEN ANONYMOUSLY

ROBERT RAUSCHENBERG was born in 1925 in Port Arthur, Tex. He briefly attended the University of Texas in 1942. From 1944 to 1946 Rauschenberg served in the U.S. Navy. He attended the Kansas City Art Institute and the Académie Julian, Paris, in 1946. Rauschenberg studied at Black Mountain College, N.C., with Josef Albers in 1948-49, and later was a student at the Art Students League, New York. His first one-man show was held at the Betty Parsons Gallery, New York, in 1951. In the following year Rauschenberg returned to Black Mountain College, where he, John Cage, Merce Cunningham, and Charles Olson produced a multi-media event, which some have characterized as the first "happening." Later in 1952 Rauschenberg traveled to Italy and North Africa with Cy Twombly and returned to New York in 1953. The same year he made his first "combines," paintings which incorporated collage elements and found objects. From 1955 to 1963 he designed stage sets and costumes for the Merce Cunningham and Paul Taylor dance companies. Rauschenberg began to make lithographs in 1962 and won first prize for a print at the Ljubljana (Yugoslavia) Biennial in 1963. In the same year he had a one-man show at The Jewish Museum, New York. He won first prize for painting in the 1964 Venice Biennale. In 1966 he was a cofounder of Experiments in Art and Technology (E.A.T.).

Bibliography:

Ashton, Dore. "Rauschenberg's Thirty-four Illustrations for Dante's Inferno," *Metro*, May 1961, pp. 52-61.

Cage, John. "On Robert Rauschenberg, Artist and His Work," *Metro*, May 1961, pp. 36-51.

Calas, Nicolas. *Art in the Age of Risk: And Other Essays.* New York: E.P. Dutton, 1968.

Forge, Andrew. *Rauschenberg.* New York: Harry N. Abrams, 1969.

Geldzahler, Henry; Cage, John; and Kozloff, Max. *Robert Rauschenberg: Paintings, Drawings, and Combines, 1949-1964.* Catalog. London: Whitechapel Gallery, 1964.

Seckler, Dorothy G. "The Artist Speaks: Robert Rauschenberg," *Art in America*, May-June 1966, pp. 73-84.

Solomon, Alan R. *Robert Rauschenberg.* Catalog. New York: The Jewish Museum, 1963.

Swanson, Dean. *Robert Rauschenberg: Paintings 1953-1964.* Catalog. Minneapolis: Walker Art Center, 1965.

Tomkins, Calvin. "Moving Out," *The New Yorker*, February 29, 1964, pp. 39-105. Reprinted in *The Bride and the Bachelors: The Heretical Courtship in Modern Art.* New York: Viking Press, 1965, pp. 189-238.

26

confronted with a series of challenges. The first of these is the idea of illustration itself. The problem for an artist in attempting to illustrate any text is that words can be resistant to visual interpretation. Their message can be totally abstract, or else ambiguous, operating on multiple levels. Furthermore, for the present-day artist, no vocabulary of conventional images is available to distinguish heroes and villains for the popular viewer. Like Dante, who alluded to specific persons and events in the Tuscany of 1300, and wrote in the vernacular rather than the literary language of the day, Rauschenberg wished to use characters of his own day to illustrate the text.

Rauschenberg begins by establishing for himself a popular imagery drawn from magazine illustrations. Many of the figures, contemporary heroes such as John F. Kennedy, are readily identifiable; others are simply representatives of industrial, space-age civilization given new identities as characters in the narrative and are recognizable from sheet to sheet. Dante and Virgil are given multiple identities, which reinforce the ambiguity of their enterprise and visually reinforce the pattern of the work as a shifting memory structure in which public, private, historical, real, and imaginary contexts are merged. The *Inferno* is the story of a quest; the use of multiple identities, repeated images, involves the viewer in a parallel quest. Dante, for instance, is frequently portrayed as a man wrapped in a towel. At other times he is a pair of eyes, a trousered leg, or kicking feet, depending on the textual description.

Virgil appears as Dante's twin, one of a pair of smiling athletes; frequently he is symbolized as an arm and hand, or appears as a spaceman, a baseball umpire, an antique statue, a scuba diver. When angry with Dante he is portrayed wearing a crash helmet. Sometimes he is symbolized simply as the initial "V." In Canto XII he appears as Adlai Stevenson, elder statesman to Dante, represented by John F. Kennedy. Beatrice, Dante's dead love and the symbol of divine love leading him to salvation, appears as an antique statue.

Rauschenberg adheres to certain traditional devices of visual narration. As in Botticelli's illustrations (and fourteenth-century Italian painting), he shows successive actions simultaneously. Each illustration reads vertically from top to bottom, downward from the upper left to lower right, "heading straight for hell. The drawing sheet is often divided into two or three parts, three paralleling the *terza rima* which Dante invented and, in turn, intended as a homage to the Trinity."[22]

T.S. Eliot has described Dante's imagination as visionary—visionary in the sense that men in the fourteenth century still had visions. The primary challenge to Rauschenberg was to find a contemporary species of the visionary with which to parallel Dante. His solution was a brilliant technical innovation, neither exclusively printing nor drawing, but a hybrid. The Dante drawings have been described as "combine" drawings; they are in fact a species of illusionary collage. Rauschenberg developed a technique for transferring to the drawing sheet already-printed images from the popular press, a process which achieves representational images without the necessity of adhering to the conventions of drawing as delineation. The transfers are achieved by moistening the drawing sheet with a solvent for printer's ink—cigarette-lighter fluid or turpentine, for instance. The reproduction is placed face down against the dampened area, and the reverse side of the reproduction is rubbed with the head of an empty ball-point pen or with a pencil. The transfer process lifts the ink with which the original reproduction was printed, color and all, so that the image appears as a species of ready-made, isolated from its context and reversed from the original.

A piece of the real world has been isolated and appropriated to art and illusion. Rauschenberg achieves his express purpose, the consistent theme of all his work. He has repeatedly made the point that he wants a picture to look what it is, and not like something it isn't, and that a picture is more like the real world when it is made out of the real world. Thus Rauschenberg dispatches the notion of illusionism. Illusion is a question of facts. The picture plane is also a fact; images may be multiplied, reversed, altered, may be imprinted upon it but only as

ROBERT RAUSCHENBERG. *CANTO XVIII.* 1959-60. WASH, PENCIL, GOUACHE, RED CRAYON, AND TRANSFER, 14 1/2 X 11 1/2" (36.8 X 29.2 CM). THE MUSEUM OF MODERN ART, NEW YORK, GIVEN ANONYMOUSLY

ROBERT RAUSCHENBERG. *CANTO XXXIV.* 1959–60.
GOUACHE, WATERCOLOR, PENCIL, AND TRANSFER,
14 5/8 X 11 1/2" (37 X 29.1 CM). THE MUSEUM OF
MODERN ART, NEW YORK, GIVEN ANONYMOUSLY

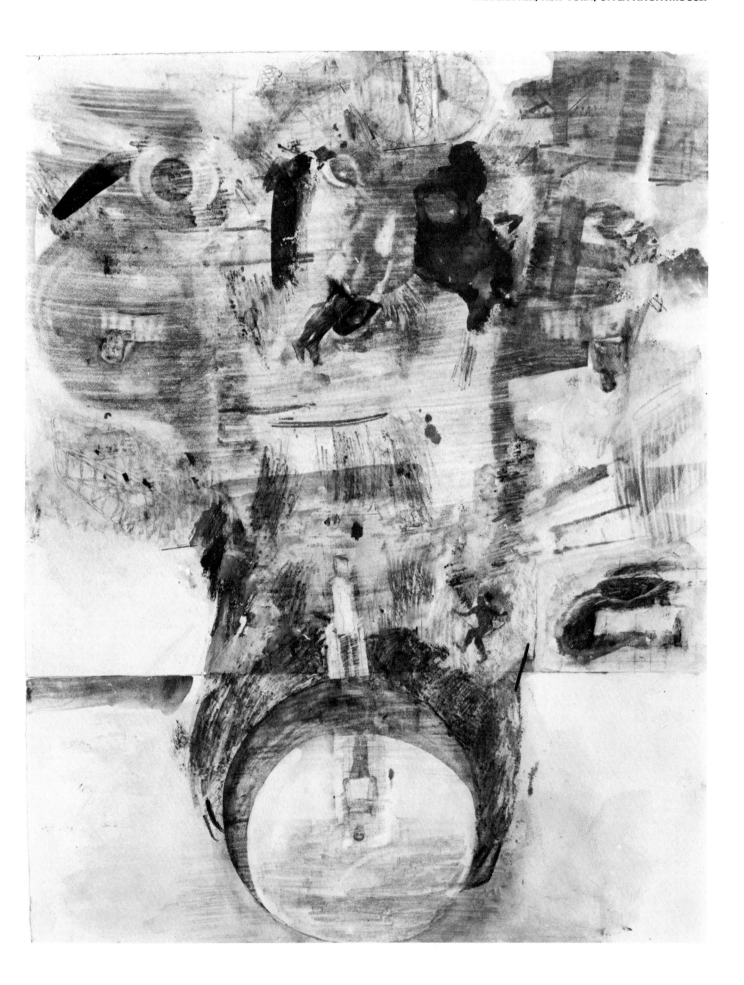

ROBERT RAUSCHENBERG. *CANTO XXXI*. 1959-60.
RED AND GRAPHITE PENCIL, GOUACHE, AND
TRANSFER, 14 1/2 X 11 1/2" (36.8 X 29.3 CM). THE
MUSEUM OF MODERN ART, NEW YORK, GIVEN
ANONYMOUSLY

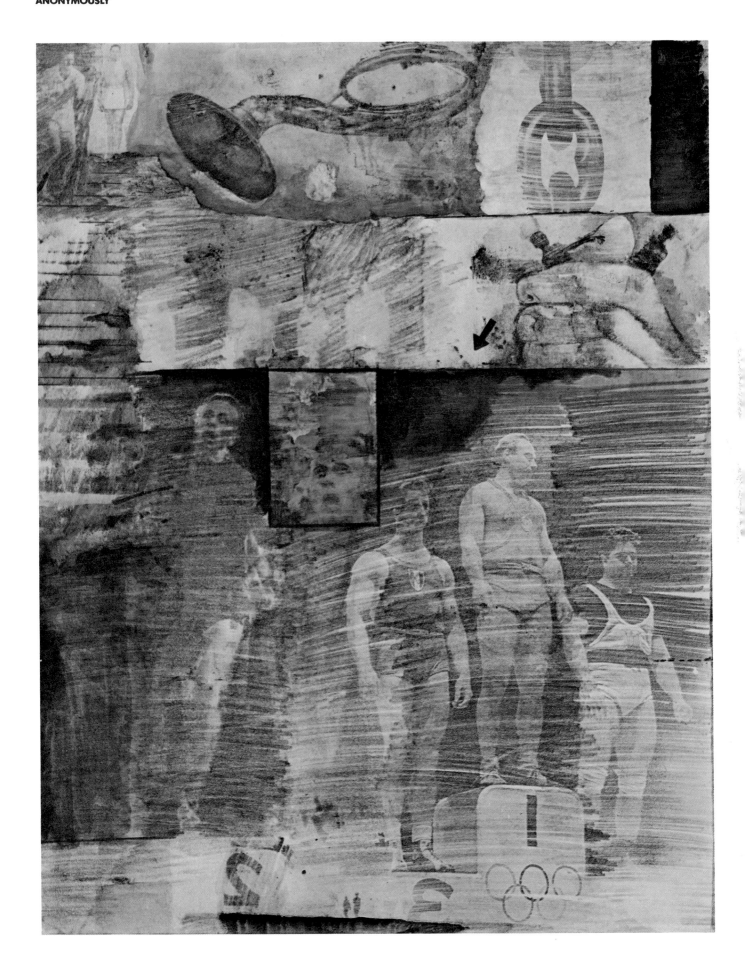

upon a screen—only touching edge to edge. Space may be altered only by cutting and shifting the plane.

Each drawing is composed of several transfers, each modified by gouache, watercolor washes, crayon, chalk, pencil, or erasures. Relationships are established and given meaning by juxtaposition, by Rauschenberg's scrabbling line, by the consistent visionary metaphor. Color, where it is deliberately applied, is used as a consistent expressive device throughout the work. Red, for instance, splashed on the page, indicates noise or emotion; it also represents the flaming and torrid temperatures of Hell. Blue sometimes suggests a desire for salvation. White, as in medieval theology, most frequently symbolizes divine light. Staccato pencil overdrawing may also indicate noise—a reminder that poetry is audible, that the world is drenched in random sound. But perhaps the most consistent expressive device in the work is the scrubbed line created by the transfer tool; the line which conjures the representation but is totally independent of it weaves its pattern through the work, changing direction, fragmenting the printed image, and asserting always the drawn quality as opposed to the printed quality of that image. It is a spiritual and artistic reclamation of the mechanical and impersonal—a reaffirmation of the Renaissance spirit of drawing as handwriting.

OBJECTS; poems as objects; objects as paintings; paintings as objects; the painting as coextensive with its subject—these concerns are implicit in Rauschenberg's art. Jasper Johns, perhaps echoing the Objectivist poets, perhaps looking to older traditions within American painting, says: "I used things the mind already knows. That gave me room to work on other levels."[23] His image is a species of ready-made; the units which form it are ready-made.

Johns's exploitation of simple images is systematic and logical at the same time that it is intuitive and searching. It amounts to an analysis of how to make a work of art if you begin with two givens: the first is the "found image"; the second is the inherited highly charged, "fast and loose" brushstroke of Abstract Expressionism.

Working with what is given, Johns initiates a new attitude—not simply a neutralized image, but a rationalization of the process of making art as well. He demonstrates (as does Rauschenberg in *Factum I* and *Factum II,* 1957) that the "unique," signatory Abstract Expressionist brushstroke is a repeatable gesture that can be rationalized and reused.

At first he uses representational images, "still life" subjects. Like Seurat, he does not use line to describe; rather, lines are organized into localized areas, building tonal sections, according to the scheme of the motif. In the Flag and Target drawings the markings of the lines correspond exactly to subdivisions of the composition. In *Three Flags* (1959), in fact, this correspondence is literal, the strokes of the farthest, largest flag being longer than those in the nearer flags—a reversal of traditional perspective.

In traditional perspective, objects farthest in space from the viewer are depicted as smaller than closer objects. Johns establishes the limits of his field of vision by making the image coextensive with the limits of the sheet. Subsidiary images depicted within the format are smaller, as is usual; but, since the original image has established the absolute physical surface and visual limits, all subsidiary images seem to be placed on top or in front, instead of receding into space. It is like saying: Recession is a bag of visual tricks that can be exposed and reversed. And Johns drives home his point about this kind of object illusionism by making a three-dimensional *Three Flags* drawing on the same principle.

But the point here is that a great deal of expressive intensity may be encompassed by a seemingly neutral scheme and a line in which expressive facility is signaled. It is the intensity of process compacted, reduced to the level of what is signaled rather than expressed openly. This intensity will henceforth be the sign of all process drawing cut loose from delineation—for while Johns's line

JASPER JOHNS. *THREE FLAGS.* 1959. PENCIL, 14 1/2 X 20" (36.8 X 50.8 CM). THE VICTORIA AND ALBERT MUSEUM, LONDON

JASPER JOHNS. *THREE FLAGS.* 1960. CARBON PENCIL ON PAPERBOARD, 11 1/4 X 16 1/2" (28.6 X 41.9 CM). COLLECTION MRS. R. B. SCHULHOF, NEW YORK

JASPER JOHNS was born in Augusta, Ga., in 1930 and spent his childhood in South Carolina. He attended the University of South Carolina for two years. In 1949 Johns moved to New York and shortly thereafter was drafted into the Army. He served in Japan from 1949 to 1952. Upon discharge Johns returned to New York. In 1954 he did his first Flag and Number paintings, which appeared in a one-man show at Leo Castelli Gallery in 1958. In 1959 he produced his first sculptures and in 1960 his first lithographs. Johns was given a major one-man exhibition at The Jewish Museum, New York, in 1964. In 1966, during a visit to Japan, his house and studio in South Carolina burned. Since 1963 Johns has been a Director of the Foundation for Contemporary Performance Arts. He has also been artistic advisor to the Merce Cunningham Dance Company and collaborated on a ballet with Cunningham and John Cage in 1973. That same year he was elected a member of the National Institute of Arts and Letters. A major exhibition of his drawings circulated in England during 1974 and 1975.

Bibliography:

Alloway, Lawrence. *American Pop Art.* New York: Whitney Museum of American Art, 1974.
Cage, John, and Solomon, Alan R. *Jasper Johns.* Catalog. New York: The Jewish Museum, 1964.
Castleman, Riva. *Jasper Johns: Lithographs.* Catalog. New York: The Museum of Modern Art, 1970.
Field, Richard S. *Jasper Johns: Prints 1960-1970.* Catalog. Philadelphia Museum of Art, 1970.
Jasper Johns: Drawings. Catalog. London: Arts Council, 1974.
Kozloff, Max. *Jasper Johns.* New York: Harry N. Abrams, 1972.
Steinberg, Leo. *Jasper Johns.* New York: Wittenborn, 1963.

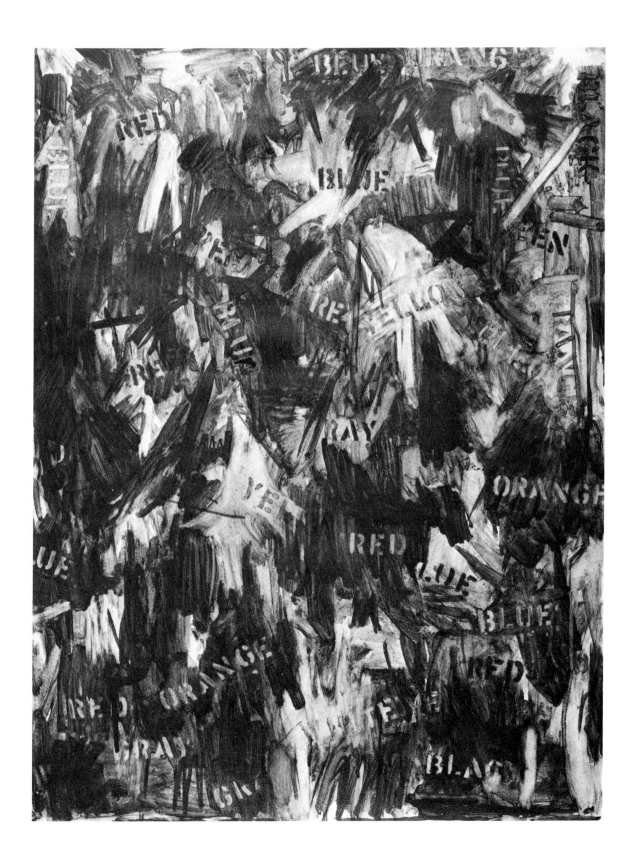

JASPER JOHNS. *GRAY ALPHABETS.* 1960. GRAPHITE
AND WASH, 32 X 23 1/2" (81.3 X 59.7 CM). COLLEC-
TION MRS. LEO CASTELLI, NEW YORK

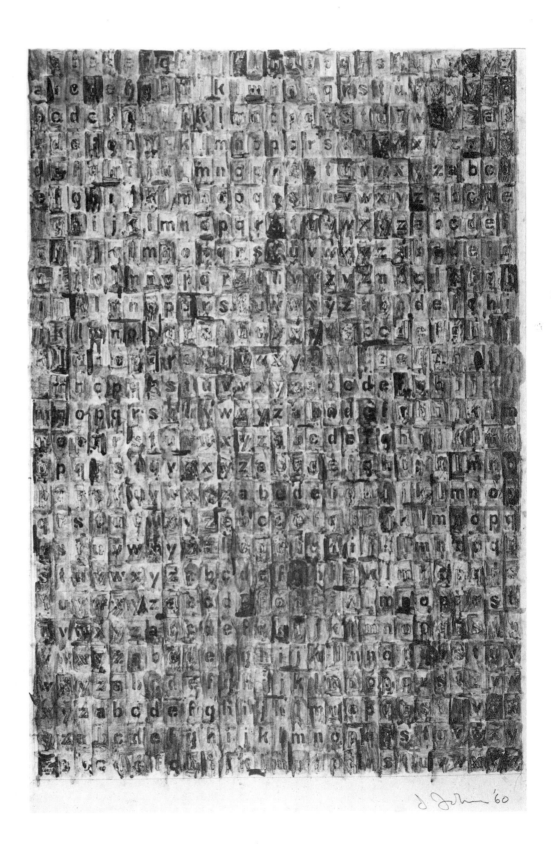

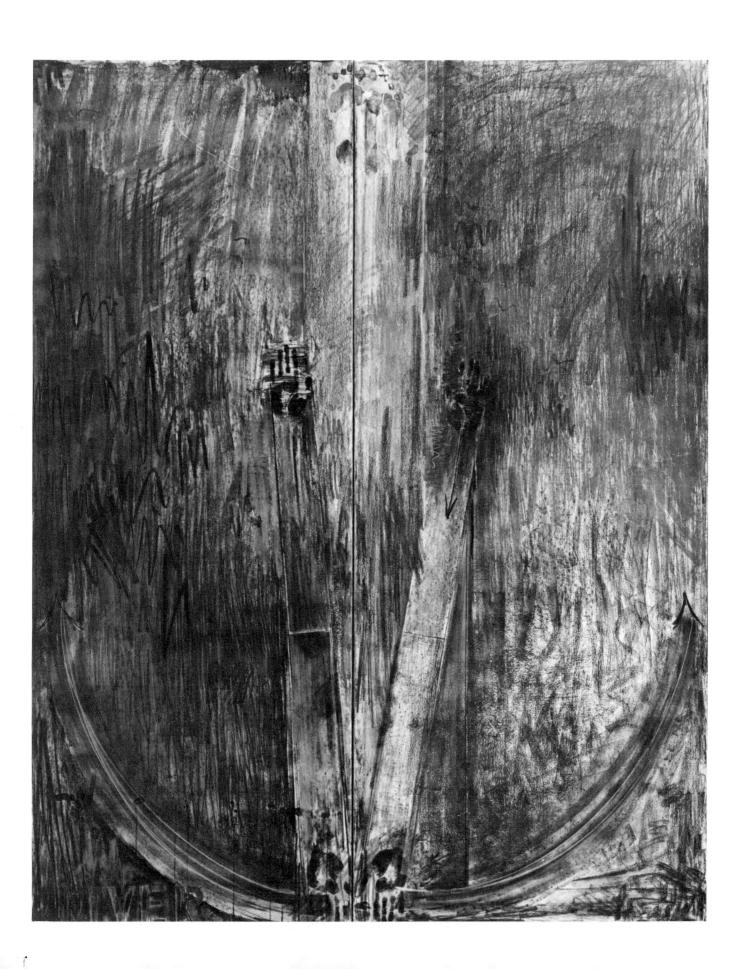

JASPER JOHNS. *DIVER*. 1963. CHARCOAL AND PAS-
TEL, 7' 2 1/2" X 71" (219.9 X 180.3 CM). COLLECTION
MR. AND MRS. VICTOR W. GANZ, NEW YORK

is coextensive with his image, it does not describe it; rather it embodies it.

When Johns wants an image within his early drawings, he uses a ready-made, and then he stencils or traces. Even when drawing freehand, Johns imitates the stencil image, insisting on stylistic coherence. His drawing strongly reminds one of Redon, of the strange apparitions which emerge from the close values of black (Redon's classic drawing, *Mask of the Red Death*, comes to mind), less so of Seurat, whose tonalities are more cerebral. While Johns appears cool, his tonalities are actually episodic, random; they constantly threaten dissolution and are resurrected by a more resolute stroke. The effect is often that of an over-all underground illumination. Johns is a master of tonal nuance. Within a single work there may be an extraordinarily varied and subtle elaboration of grays, so skillfully handled as to suggest color nuances. Johns sees in terms of black-and-white; tone is color. His use of color is therefore tonal. While there is a very large range of darks and lights in his work, the effect is that of modulation; direct, dramatic oppositions of light and dark are nonexistent.

Johns is also a master of a great range of graphic mediums, from extremely traditional ones to very painterly ones. In addition to pencil, he uses powdered graphite and brush, charcoal—*Diver*, one of his most important drawings, is made by dragging a charcoal-powdered rag over the surface of a paper laid on a rough ground. Pastel and sculpmetal are also among the mediums he employs. Interestingly, he uses collage as a base for painting. There is an area of his work in which distinctions between painting and drawing become arbitrary, so close is his association of the paint stroke and the drawing stroke; his vision in painting is essentially that of the gestural draftsman.

Johns's drawings are in a special relationship to his paintings. There are drawings for paintings and then there are finished drawings after paintings. *Jubilee* is a drawing after a painting.

Johns's drawings are questions about essences, about how the thing is made. *Jubilee* is in one sense a drawing about drawing as a study for painting—how a tonal, linear exercise relates to a painterly, colored object. It is an examination—once again—of Cézanne's statement: "Drawing and painting are no longer different factors: as one paints one draws: the more harmony there is in the colors the more precise the drawing becomes....When the color is at its richest, form is at its fullest."

Maurice Merleau-Ponty quotes Cézanne's famous statement about color and drawing in an essay entitled "Cézanne's Doubt." He goes on to say: "Cézanne did not try to use color to *suggest* the tactile sensations which would give form and depth. In primordial perception distinctions between sight and touch are unknown: the science of the human body taught us later to distinguish between our senses. The thing lived is not found or constructed on the basis of sense impressions but offers itself to us, right away, as the center from which they radiate. We see the depth, the downiness, the softness, the hardness of objects—even, Cézanne said, their smell."[24]

Like Cézanne, with whose questioning of the structure of Impressionism we must equate Johns's questioning of Abstract Expressionism, Johns goes on to question more and more the difference between tactile and visual sensations—the essential opposition which creates illusionism.

Literal image, literal object, and finally literal scale. *Diver*, one of a group of works connected with the poet Hart Crane, who died by drowning, is an "exercise" in literal scale. The primary game for Johns—for the century—has been identified as illusionism. The prime illusion is tactile, rendering three-dimensional objects on a two-dimensional plane so that they retain the appearance of physicality and assert themselves within the space "as so real that one could touch them"—as Alexander tried to touch the fly painted by Apelles. The footprints and handprints, the sweep of the arms in *Diver* are direct impressions of the artist's hands and feet on the drawing in literal scale. The question is: Can the diver dive through the picture plane? More acutely, on which side of the picture plane is he? Is he through the window or only reaching for it? Does the sweep of his arms record the opacity or transparency of surface? The

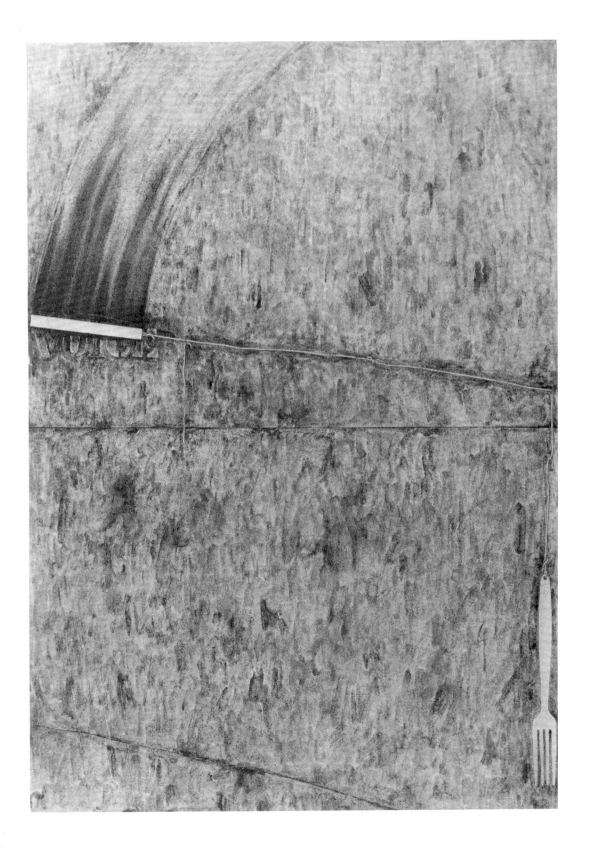

question is one of pictorial facts. The soft, random scrolling of the charcoal surface with the light shining through from the ground behind offers no answer, confounds the issue, but the physical division of the drawing into two distinct halves is a statement of the fact that the drawing is an object, that the connection to the real world is maintained as a fact.

For the philosopher Ludwig Wittgenstein the question of illusion was also primary, although his questions were about the illusions of words. Johns's questions about illusion and tactility are very much like Wittgenstein's. Johns had begun to read Wittgenstein in 1961. But even before reading him Johns had formulated questions about the nature of words and pictures—about how a word could function as a visual image—or to create an image. Johns, in fact, adopts the use of words in conjunction with the painted image, a practice which becomes more important to Pop art and eventually emerges as an independent branch of the visual arts. A section of Wittgenstein's early work, *Tractatus Logico-Philosophicus*, is a fascinating counterpoint to *Diver*:

Pictorial form is the possibility that things are related to one another in the same way as the elements of the picture
That *is how a picture is attached to reality; it reaches right out to it*
It is laid against reality like a measure
Only the end-points of the graduating lines actually touch the object that is to be measured
So a picture also includes the pictorial relationship, which makes it into a picture
The pictorial relationship consists of the correlations of the picture's elements with things
These correlations are, as it were, the feelers of the picture's elements with which the picture touches reality
If a fact is to be a picture, it must have something in common with what it depicts
There must be something identical in a picture and what it depicts, to enable the one to be a picture of the other at all[25]
Diver is perhaps the most ambitious drawing of the past twenty years—like the Seurat *Portrait of Aman-Jean*, "a manifesto of the independence of draftsmanship."

For Johns, despite his use of existing images as ready-made signs, the question of style—of how to render—functioned with reference to the preceding generation. Johns's facture was a reorganization of the expressionist strokes of Abstract Expressionism in relation to subject. As Stella notes in terms of Pollock and de Kooning, Johns draws with a brush. For the Pop artists immediately following Johns and Rauschenberg the problem of style was more complex. A new subject matter had been made available by Johns and Rauschenberg, but it was handmade or had the patina of use. The next step was a direct relationship between art and the commercialized, mechanical urban-suburban complex of images. The new range of subject matter, in radical opposition to Newman's "subject matter that is tragic and timeless," dealt with the products of a consumer society (kitsch and humor were important ingredients): hamburgers, slices of pie, neckties, comic strips, billboard advertisements. All of these images were filtered through the mass media; they were portrayed as pictured elsewhere (usually through graphic techniques), not as they appeared in real life. Style seems to have become available in the same way as image (as a ready-made)—high style for low images through parody.

Abstract Expressionism was concerned with one kind of risk-taking; the artist staked all on the drama of self-expression, on revelation as a moral issue. Now taste became an issue: accepting what had been unacceptable, absorbing the vulgar back into high art.[26] The stakes were set in terms of art and style itself. Andy Warhol set the terms of the artist who refused to allow good taste (and Abstract Expressionism seemed awfully good taste by the late fifties) to interfere in the making of a work of art and rejected the personal in terms of

JASPER JOHNS. *VOICE*. 1969. GRAPHITE, 36 1/4 X 27 1/2" (92.1 X 69.8 CM). COLLECTION OF THE ARTIST

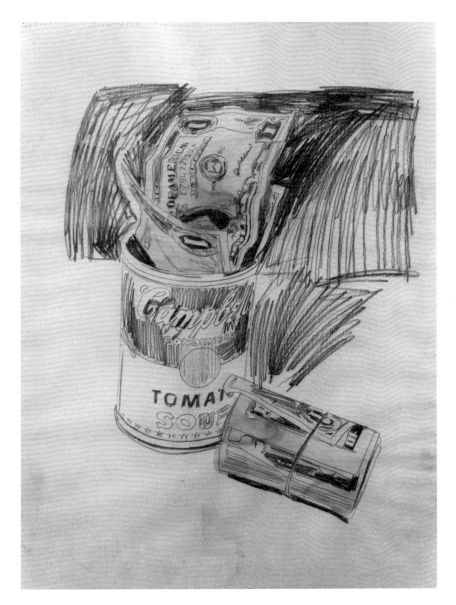

ANDY WARHOL. *CAMPBELL'S SOUP CAN AND DOL-LAR BILLS.* 1962. PENCIL AND WATERCOLOR, 24 X 18" (61 X 45.7 CM). COLLECTION ROY AND DORO-THY LICHTENSTEIN, NEW YORK

ANDY WARHOL was originally Andrew Warhola, born to Czechoslovakian parents in Pittsburgh in or around 1930. From 1945 to 1949 he was a student at Carnegie Institute of Technology, Pittsburgh, where he majored in pictorial design. After graduation Warhol moved to New York and worked as a commercial artist. His first one-man exhibition, at the Hugo Gallery, New York, in 1952, consisted of fifteen drawings based on the writings of Truman Capote. In 1960 Warhol began to make his acrylic and silk-screen paintings, introducing comic-strip and advertising images in his works. His first one-man exhibition of paintings was held in 1962 at Ferus Gallery, Los Angeles. Since 1963 Warhol has made numerous films. He has had several major retrospectives in Europe and the U.S.

Bibliography:

Coplans, John; Mekas, Jonas; and Tomkins, Calvin. *Andy Warhol.* Greenwich, Conn.: New York Graphic Society, 1970. Published on occasion of an exhibition at the Pasadena Art Museum and later circulated to Chicago, Eindhoven, Paris, London, and New York.
Crone, Rainer. *Andy Warhol.* New York: Praeger, 1970.
Gidal, Peter. *Andy Warhol: Films and Paintings.* London and New York: Studio Vista/Dutton, 1971.
Hahn, Otto. *Warhol.* Paris: Fernand Hazan Editeur, 1972.
Morphet, Richard. *Andy Warhol.* Catalog. London: The Tate Gallery, 1971.
Warhol, Andy. *The Philosophy of Andy Warhol (From A to B and Back Again).* New York: Harcourt Brace Jovanovich, 1975.
Warhol, Andy; König, Kasper; Hultén, K. G. Pontus; and Granath, Olle, eds. *Andy Warhol.* Catalog. Stockholm: Moderna Museet, 1968.

OPPOSITE:

CLAES OLDENBERG. *FLAG TO FOLD IN THE POCKET.* 1960. INK, 29 1/2 X 47" (74.9 X 119.4 CM). COL-LECTION OF THE ARTIST

ROY LICHTENSTEIN. *10¢.* 1962. INK, 22 1/2 X 30" (57.1 X 76.2 CM). COLLECTION CY TWOMBLY, ROME

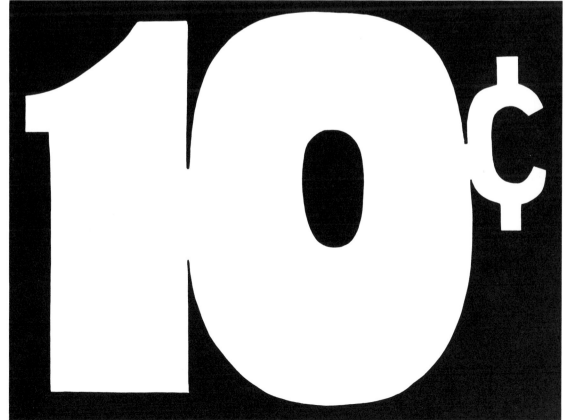

the handmade. Finish, so high it was depersonalized, was pitted against the poetic unfinished surfaces of preceding art. His unique creation is a totally identifiable personal style achieved through the use of mechanical technique. His Campbell soup cans are exact mirrors of secondhand reality. His work is reportage straight out of the mass media without the mediation of personal memory as it intervenes in Rauschenberg's work. Warhol started out as a commercial artist—for "commercial" read "graphic," because the graphic media were the basis for a great deal of commercial art in the fifties. His transitional work included drawings of dollar bills, Campbell soup cans, and baseballs, and paint-it-yourself diagrams, rendered in awkward, ugly line, as if in disdain for the handmade. He then turned to techniques for the commercial reproduction of images, serigraphy and photoserigraphy primarily. His involvement with commercial techniques was a direct avoidance of the handmade, a total break with tradition. He wants to be a machine that makes art—or have someone else do it. His paint-by-the-numbers image is a direct statement about his contempt for the handmade; he implies that anyone can draw—but not everyone can think.

For Lichtenstein and Oldenburg the issue was somewhat more complex, the solution not quite as radical, their ties to tradition remaining unbroken. Theirs is an art about art as style and about the possible uses of tradition.

Roy Lichtenstein's reliance on drawing is crucial, although the number of finished, independently conceived drawings within his oeuvre is relatively small. The greater number of Lichtenstein's drawings function as studies. Recently he has worked a great deal in collage, using it to make maquettes to be mechanically reproduced as prints. Drawing functions within Lichtenstein's work primarily as contour; the structure of his painting is established by black contour drawing with brush and acrylic paint. Lichtenstein has conceded his ambition to revolutionize his art through traditional procedures. His composition is traditional—centrally, hierarchically organized, in relation to the framing edge—but he undermines the handmade look of drawing by imitating commercial reproduction procedures. The most characteristic of these is the benday dot, a commercial dotted transfer printed pattern. In commercial graphic studios the benday dot, zip-a-tone transfers, and other mechanical reproduction devices are dropped into a handmade contour drawing to indicate areas of tone and shading. But Lichtenstein hand-draws the benday dot, sometimes using stencils, sometimes creating the dots by rubbing through a screen. Whatever the method, the intention is a reversal—a subtle handmade reproduction of the mechanical. His contour line is a stereotype; like the traditional line it quotes, it grows and diminishes as it flows, providing formal and emotive emphasis. His independent drawings are black-and-white reductive reorganizations of the already simplified images of comic strips, which, as Lichtenstein points out, are unwitting reductions of "high" art styles —like the Art Nouveau flames coming out of the machine-gun muzzle. Lichtenstein then "pushes a reference like this a little further until it's a reference most people will get."[27] His style is one of utmost reduction, a reorganization to eliminate the unnecessary and sharpen the essential. With time, Lichtenstein's first, almost shockingly boring, deliberately "bad" drawing style sharpens so that boring drawing itself takes on an edge of authority, creating a style of some elegance. By fulfilling the terms of its own internal logic, it achieves a sense of completion and aesthetic rest fully satisfactory on any terms.

Lichtenstein's study drawings reveal the full range of his imagery—cartoons, objects as varied as balls of twine, haystacks, cathedrals, barns, brushstrokes, other style eras (for instance, the thirties), other paintings. The sketches are exemplary of his sensitivity to scale; tiny, many of them no larger than a few inches across, they are nevertheless astonishingly complete, and unlike his independent drawings they are in color. Diane Waldman has described how Lichtenstein arrives at these sketches and how they are used: Lichtenstein "selects motifs from illustrations or other secondhand sources and recomposes

ROY LICHTENSTEIN. *JET PILOT.* 1962. PENCIL AND RUBBING, 22 X 23 1/8" (55.9 X 58.7 CM). YALE UNIVERSITY ART GALLERY, NEW HAVEN, CONN., ON LOAN FROM RICHARD BROWN BAKER

ROY LICHTENSTEIN was born in 1923 in New York City. In 1939 he studied at the Art Students League, New York, under Reginald Marsh. In 1940 he entered Ohio State University, Columbus, as an art major. His schooling was interrupted in 1943 by a period in the Army; he served as a cartographical draftsman. Lichtenstein resumed classes at Ohio State in 1946 and received his B.F.A. the same year, his M.F.A. in 1949. He also taught drawing and painting at the university until 1951. His first one-man exhibition was held in 1951 at Carlebach Gallery, New York. Lichtenstein lived in Cleveland, Ohio, from 1951 to 1957, working as a free-lance designer and painting on his own. He taught studio art classes at the State College at Oswego, New York (1957-60), and Douglas College, Rutgers University, New Jersey (1960-63). During the early 1960s Lichtenstein made his first comic-strip images. He has had major one-man shows at The Tate Gallery, London (1968), The Solomon R. Guggenheim Museum, New York (1969), and a show of drawings at the Centre National d'Art Contemporain, Paris (1975).

Bibliography:

Alloway, Lawrence. "Roy Lichtenstein's Period Style," *Arts Magazine*, September-October 1967, pp. 24-29.
Boatto, Alberto, and Falzoni, Giordana, eds. *Roy Lichtenstein*. Rome: Fantazario, 1966.
Coplans, John, ed. *Roy Lichtenstein*. New York: Praeger, 1972.
Waldman, Diane. *Roy Lichtenstein*. Catalog. New York: The Solomon R. Guggenheim Museum, 1969.
Waldman, Diane. *Roy Lichtenstein*. New York: Harry N. Abrams, 1971.
Waldman, Diane. *Roy Lichtenstein: Drawings and Prints.* New York: Chelsea House, n.d.

these images, small in scale, into equally small sketches, by means of an opaque projector. …the sketch is enlarged to the scale of the canvas and transferred, it is [then] subject to a series of changes—of drawing shape and color sequences."[28] The sketches are thus preparatory drawings in the most traditional sense. They also document "the consistency of Lichtenstein's style" and function satisfactorily as miniature drawings in their own right.

Lichtenstein's collages, too, are brilliant stylistic essays in the classical collage style, in which plane, color, and contour are established by the single operation of cutting. In Lichtenstein's work, collage functions as a mode of planar, colored contour drawing: Matisse's "drawing with scissors."

Lichtenstein is not an "abstract" painter. For him, subject is primary. He refuses to work without an image to refer to, and the image must have some "history" in art, must already exist in some form in art. His earliest images are drawn from graphic art, and are directly dependent on drawing; he derives his more recent ones from high art. Even his more recent paintings—quotations of paintings by such masters as Matisse and Léger—are executed in terms of his original technique of the black outline filled with primary color. Rauschenberg and Johns conceived of their images as mundane; Lichtenstein conceives of his images as a cliché. Like Warhol, he perceived that images of the world which had been vulgarized by the popular media could serve high art once again since they had become emblematic through overuse as clichés.

All of Lichtenstein's images become stereotypes. They may also in one sense be described as Platonism turned in on itself. Plato wished to "reduce the visual world to unalterable, universally and eternally valid form, thus renouncing the individuality and originality in which we are accustomed to find the principal criterion of artistic accomplishment…"[29] Lichtenstein does this through the stereotype. He could also be described as operating at Plato's "third remove from truth," with imitations of imitations, illusions of illusions: "Either the artist produces copies conscientious at best of given objects, in which case his copying exactly produces the components of sense—perceptible reality—but absolutely nothing more than the components of sense—perceptible reality—and this would amount to a pointless duplication of the world of appearances, which in turn only imitates the world of ideas; or he begets unreliable and deceptive illusions, which by way of copying imaginatively make the large small and the small large in order to mislead our imperfect eyes, and then his product increases the confusion in our soul; its truth value is less than even that of the world of appearances, a third remove from truth."[30]

Lichtenstein's series of bull collages (studies for prints), based on van Doesburg's famous reduction of a naturalistic cow to a purely abstract schematization, is a perfect example of turning the Platonic "idea" on itself. Van Doesburg's series starts with a copy of a given object in nature—of the world of appearance, illusions—to arrive at what van Doesburg would consider a version of Plato's universally valid forms: cubes and rectangles in primary colors which the process of his rationalization informs us could apply to any image. Lichtenstein starts from a different point, an image already placed within the art context, and proceeds to make it even "artier." He exposes the completely arbitrary nature of van Doesburg's assumptions and declares that art is about art, that it is an illusion about an illusion—that the true subject is in that place at a third remove from truth, but in that third remove from truth lies Plato's "idea."

Lichtenstein's early work, like photography, exploits the notion that pictures can tell a story—he even supplies words to clarify the action, sharpen the cliché. His images present emotion distanced by overfamiliarity, so that we feel no connection—a kind of knee-jerk sentimentality.

The early work is about one kind of illusion in art, story-telling "realism." The later work is about art itself as a process of illusionism. Lichtenstein's need is to sublimate that process to his paradoxically neutral style—to eliminate the emotive and the personal in order to achieve a distance from the constant pressure of the images which form the day-to-day world.

ROY LICHTENSTEIN. *TABLET.* 1966. PENCIL AND TUSCHE, 30 X 22" (76.2 X 55.9 CM). COLLECTION MRS. RICHARD SELLE, NEW YORK

ROY LICHTENSTEIN. BULL SERIES. 1973. PRIVATE COLLECTION, NEW YORK

BULL I. INDIA INK OVER DRY MARKER, 28 X 38 1/8" (71.1 X 96.8 CM)

BULL II. COLLAGE AND INDIA INK, 27 1/4 X 35 1/4" (69.2 X 89.5 CM)

BULL III. COLLAGE, INDIA INK, AND SYNTHETIC POLYMER PAINT, 28 X 37 1/4" (71.1 X 94.6 CM)

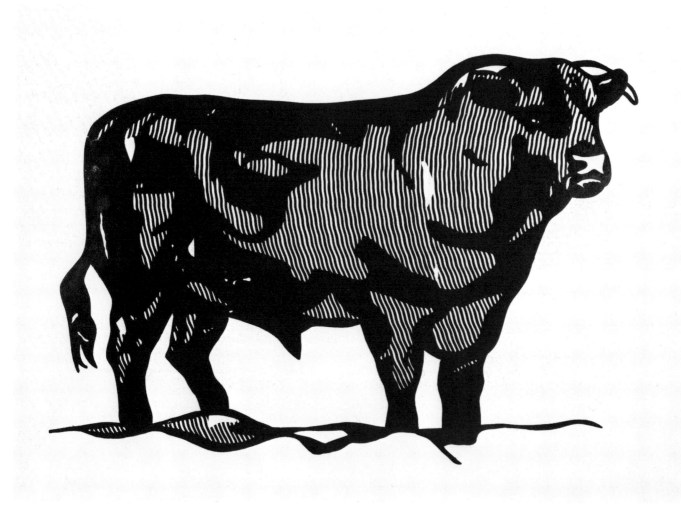

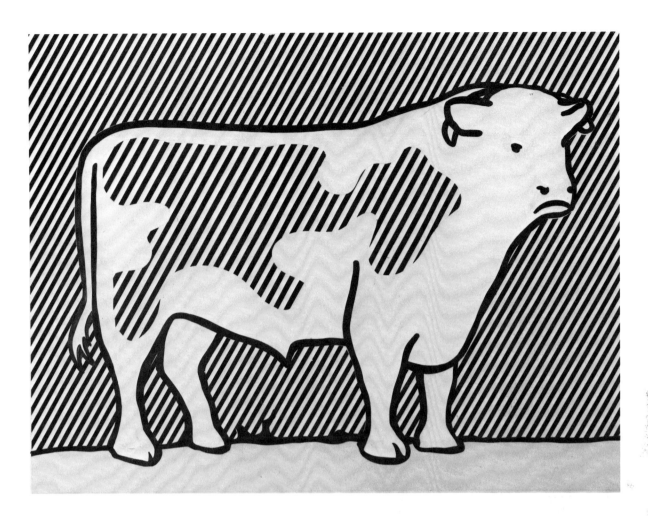

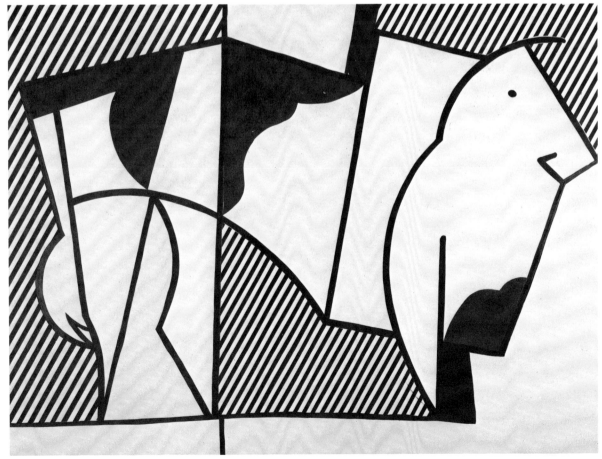

ROY LICHTENSTEIN. BULL SERIES. 1973. PRIVATE
COLLECTION, NEW YORK

BULL IV. COLLAGE, INDIA INK, AND SILKSCREEN,
23 3/8 X 33 1/8" (59.4 X 84.1 CM)

BULL V. COLLAGE AND INDIA INK, 23 1/2 X 33 5/8"
(59.7 X 84.1 CM)

BULL VI. 1973. COLLAGE, INDIA INK, SYNTHETIC
POLYMER PAINT, AND PENCIL, 25 X 33 1/4" (63.5 X
84.5 CM)

Lichtenstein's is not the first style in which the need for distance and detachment is felt—Johns's supplies it in a wholly different way. But as a formal proposition it will inform most of the art that follows. The cool hard-style and his exposure of illusionism feed right into the work of the slightly younger Minimal artists.

His depersonalization of the handmade quality of drawing amounts to a major reappraisal of the possibilities of that medium in terms of its traditional stance. Perhaps at that point, drawing—which despite Johns and Rauschenberg had been regarded with some suspicion ever since the forties as the refuge of the conservative artist, as a mere skillful exercise—could be described as being reexamined through a sense of ironic detachment and a parodying of its traditional forms and possibilities. For Lichtenstein, like Johns and Rauschenberg, drawing had come to be an essential part of the making of his art—the core of his style. That could also describe, at least partially, Claes Oldenburg's approach to drawing.

As a sculptor Oldenburg has created—besides his three-dimensional pieces— a large body of work that exists only on paper: the propositions for public monuments. These are the drawings for which he is best known. But Oldenburg draws prolifically, carrying a sketchbook and noting ideas as they occur to him. He uses drawing for every purpose, drawing in one mode as comfortably as in another; he even draws on his sculpture. Oldenburg has said that his art objectifies his fantasies; the monument series operates within his oeuvre in this way. Portrayals of colossal objects set into the landscape as gargantuan landmarks seen from a distance, they are related to a long tradition of drawing of fantastic architectures and yet are totally unexpected in their subject matter.

There is, however, an aspect of Oldenburg's drawing which, within the period under discussion, is unique in its attitude to the medium, and it is this I would like to focus on. Irony and parody play a large part in his sculptural style. The very concept of soft sculpture is in itself ironic and subversively funny. When in addition his work portrays objects of the everyday environment (like hamburgers) decontextualized as fragments, and portrays only fragments of the human body, it proposes new attitudes toward forms and materials and their traditional relationships in art. Oldenburg has described this attitude as "parody." He explains that parody in the classical sense is simply a kind of imitation, something like a paraphrase. It is not necessarily making fun of anything; rather it puts the imitated work into a new context.[31]

Oldenburg has consistently explored the idea of style through drawing. He has said, "The view I have of style rests on the many different experiments with drawing made before 1958."[32] Since that time he has seriously examined the question of the style of drawing itself. Between 1965 and 1967 he executed a series of drawings which "paraphrase" drawing in "the grand style." He feels that in our day it is only in drawing that the human figure can be portrayed— that in sculpture the human figure, except as a fragment, has become impossible to present. (This is because there is to the human body a *relational* structure that is unavoidable; one of the characteristics of Oldenburg's sculpture is that the major part of it consists of whole objects or ensembles of whole objects, not objects in parts.) In drawing, however, the human figure "has a legitimate place through the illegitimate channel of pornography."[33] Out of this context emerge several drawings, two of them extraordinary portrayals of nude women: *Stripper with Battleship*, a proposed illustration, and *Nude: Three-Way Plug*, a seemingly independent drawing. The nude is the most traditional and basic drawing subject available in art. To draw a traditional subject one calls on a traditional style, and for these drawings Oldenburg called on the Baroque. He recalls having been earlier "seduced by artificiality, starting with Bernini in Rome."[34] The figures in the drawings are rendered as tactile, but the line that casts the forms into depth and shadow emerges to race across the paper surface, reestablishing the plane. Oldenburg reiterates the notion that

CLAES OLDENBURG. *PROPOSED COLOSSAL MONUMENT FOR TORONTO: DRAINPIPE.* **1967. PENCIL AND WATERCOLOR, 40 X 26" (101.3 X 65.9 CM). COLLECTION MR. AND MRS. HARRY KLAMER, WILLOWDALE, ONTARIO**

CLAES OLDENBURG was born in 1929 in Stockholm. His father was a Swedish diplomat, and his family lived in New York and Norway before settling in Chicago in 1936. Oldenburg studied art and literature at Yale University from 1946 to 1950. He returned to Chicago after graduation and remained there until 1956. He continued his training in art at The Art Institute of Chicago. In 1952 he became a U.S. citizen. Oldenburg moved to New York in 1956 and worked part-time in the library of the Cooper Union Museum and Art School until 1961. His first one-man shows were held at the library and the Judson Gallery in 1959. He participated in numerous "happenings" in the 1960s. In 1961 Oldenburg opened The Store, an "environment" composed of works depicting merchandise available in local shops. The first exhibition of his large-scale soft sculptures took place in 1962. He began to make monument drawings in 1965 and has continued to make them to the present. The Museum of Modern Art organized a comprehensive exhibition of his work in 1969. In 1972 Oldenburg realized one of his more ambitious projects in the structure of the Mouse Museum at the Documenta 5 exhibition in Kassel, Germany. In 1975 Oldenburg published a group of erotic etchings after earlier drawings.

Bibliography:

Alloway, Lawrence. *American Pop Art.* Catalog. New York: Whitney Museum of American Art, 1974.
Baro, Gene. *Claes Oldenburg: Drawings and Prints.* New York and London: Chelsea House, 1969.
Carroll, Paul. *Proposals for Monuments and Buildings 1965-69.* Chicago: Big Table Publishing Company, 1969.
Friedman, Martin. *Oldenburg: Six Themes.* Catalog. Minneapolis: Walker Art Center, 1975.
Haskell, Barbara. *Claes Oldenburg: Object into Monument.* Catalog. Pasadena Art Museum, 1971.
Johnson, Ellen H. *Claes Oldenburg.* Baltimore: Penguin Books, 1971.
Rose, Barbara. *Claes Oldenburg.* New York: The Museum of Modern Art, 1970. Published in conjunction with exhibition, 1969.

BELOW: CLAES OLDENBURG. STRIPPER WITH BAT-TLESHIP: STUDY FOR "IMAGE OF THE BUDDHA PREACHING" BY FRANK O'HARA. 1967. PENCIL, 30 1/8 X 22 1/8" (76.4 X 56.1 CM). THE MUSEUM OF MODERN ART, NEW YORK, ANONYMOUS GIFT

OPPOSITE: CLAES OLDENBURG. NUDE: THREE-WAY PLUG. 1967. PENCIL, WATERCOLOR, AND GOUACHE, 40 1/8 X 26 1/4" (101.7 X 66.5 CM). PRIVATE COL-LECTION, NEW YORK

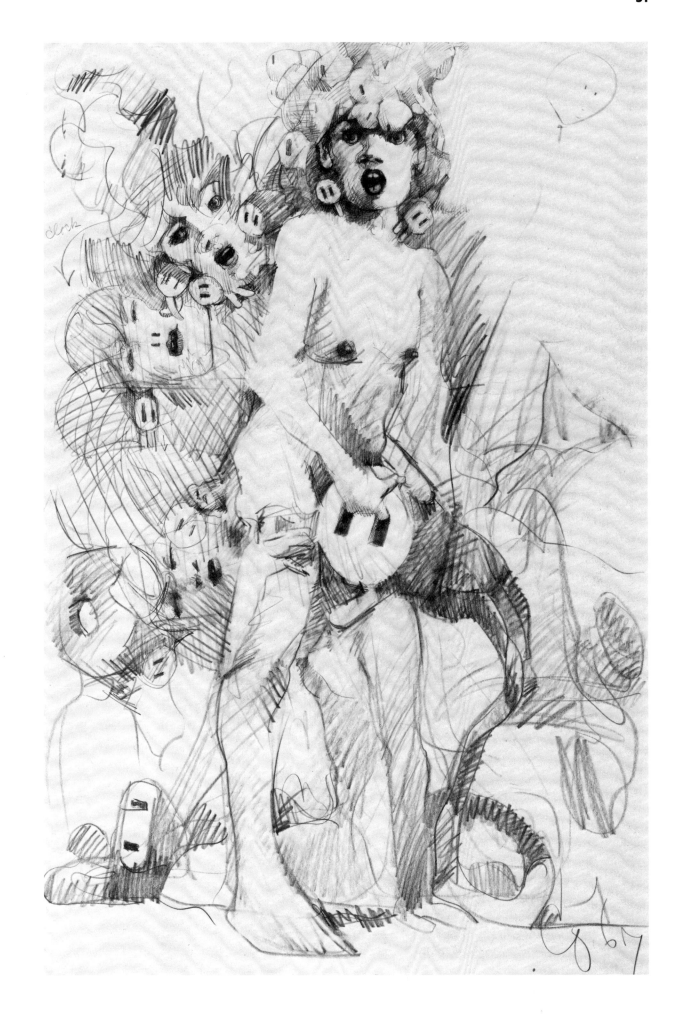

if drawing is "truly rooted in the artist's body—his particular vision or other physical facts—the character of his gesture and his temperament—the whole work will show a unity throughout the changes."

"Each style is a new discipline," he believes, "a new example, and grows from a primitive stage through a perfect one to a state of decline. These changes are based on the facts of the artist's changing situation."[35] It is also a fact of the artist's changing situation that a grand style today can only be convincing as a parody, as a paraphrase; it is simply not available to contemporary artists except as an irony. The *Nude: Three-Way Plug* is one of Oldenburg's most ambitious drawings, strongly evocative of a nineteenth-century Salon picture. More specifically, the nude is perhaps a kewpie-doll parody of the lovelies that Ingres portrayed in his monumental *Bain Turque,* an allegory of the senses that flirts with the pornographic. In the Oldenburg the nude's red tongue may be a direct quote, but is far more explicit than the underground suggestiveness of the Ingres. What I am proposing is that this drawing is a deliberate return to tradition and quotation of grand style as a liberating device. Oldenburg relates very strongly to the traditional ideas of drawing. Among other traditional ties of technique to which he himself calls attention is the use of the white paper as a source of light.

He is sensitive to the way the pencil pulls on the surface, to the difficulties of controlling the specific densities of line. Writing about *Stripper with Battleship,* which was executed as a memorial to the poet Frank O'Hara, he notes that "the perversity of rendering in fine line on paper suited to rough line" imposed a kind of stylistic frustration appropriate to the subject—"a small suffering" out of respect for O'Hara, plus "the satisfaction of perversity per se."[36] Hard lines are generally reserved for factual drawing, preliminary rendering for sculpture. The two drawings of nudes display the full range of hard to soft lines. Oldenburg is especially sensitive to scale in drawing—"a large part of the pleasure of drawing is the awareness of shifting scale."[37] *Stripper with Battleship* records actual scale changes; *Nude: Three-Way Plug* is monumental in effect.

One of the long-recognized attractions of drawing has been its "incompleteness," dependent on the moment when the artist let go, prompting the viewer to complete the broken line, the sketchily indicated hand or limb. I started by saying that in sculpture Oldenburg could treat the human figure only as a fragment, but in drawing, the most intimate medium, by resorting to tradition he could reconstitute the figure with all its sexual implications. Modern analysis tells us that there is a stage in our lives when bodily images are introjected into our unconscious as fragments, that through an act of the will we re-form them as a whole, at the same time reconstituting our world-view; it is the peculiar task of art to reenact this process time after time, always in new ways. Our aesthetic pleasure in the work of art lies precisely in following the artist through this reenactment. When an artist goes explicitly through this process, as does Oldenburg, the excitement of following the process is sharpened if at times, adhering to the tradition, he leaves something for us to complete. It is Oldenburg's particular gift that, for all the technical mastery of the extraordinary line and its capacity for explicit description, he knows when to leave off and merely suggest, permitting our active participation in his unique creation.

David Hockney and Jim Dine have both come more and more to approach drawing from examination of tradition. The earlier drawings of both artists betray a mistrust of skillful drawing. Hockney's in particular quote the schoolboy "scratch" tradition of Alfred Jarry's drawings for *Ubu Roi,* for which he has designed sets. Dine's early images, too, are defined in terms of the scrawl or scratch, but recent work is breathtakingly skillful, elegiac in its Rembrandtesque evocation of tools elevated to the status of still-life objects. Hockney has become a master of the portrait drawing—that most intimate and revelatory form of drawing. But Hockney's portraits are both personal and detached at the same time; they expose intimate glimpses both more nakedly and more sentimentally than has been acceptable. His drawing, in general, constantly

OPPOSITE, ABOVE: RICHARD HAMILTON. STUDY FOR THE SOLOMON R. GUGGENHEIM MUSEUM. 1965. CRAYON AND SYNTHETIC POLYMER, 20 X 23" (50.7 X 58.4 CM). THE MUSEUM OF MODERN ART, NEW YORK, GIFT OF MR. CHARLES B. BENENSON

RICHARD HAMILTON was born in 1922 in London. In 1936 he worked in advertising while attending art classes at Westminster Technical College and St. Martin's School of Art. From 1938 to 1940 he studied painting at the Royal Academy Schools, London. During the war Hamilton was employed as an engineering draftsman. In 1946 he resumed studies at the Royal Academy Schools but was soon expelled for "not profiting by the instruction given at the Painting School." Upon leaving school, he served in the military for eighteen months. From 1948 to 1951 Hamilton studied at the Slade School of Fine Art. His first one-man show was held in 1950 at Gimpel Fils, London. In 1951 Hamilton organized his first exhibition at the Institute of Contemporary Arts and the following year joined the Independent Group. He came to the U.S. in October 1963 and in 1965 did a series of drawings based on the image of the Guggenheim Museum. He had a major one-man show at The Tate Gallery, London, in 1970.

Bibliography:

Baro, Gene. "Hamilton's Guggenheim," Art and Artists, November 1966, pp. 28-31.
Finch, Christopher. "Richard Hamilton," Art International, October 1966, pp. 16-23.
Morphet, Richard. Richard Hamilton. Catalog. London: The Tate Gallery, 1970.
Russell, John. Richard Hamilton. Catalog. New York: The Solomon R. Guggenheim Museum, 1973.
Russell, John. Richard Hamilton: Prints, Multiples and Drawings. Catalog. Manchester, England: Whitworth Art Gallery, University of Manchester, 1972.

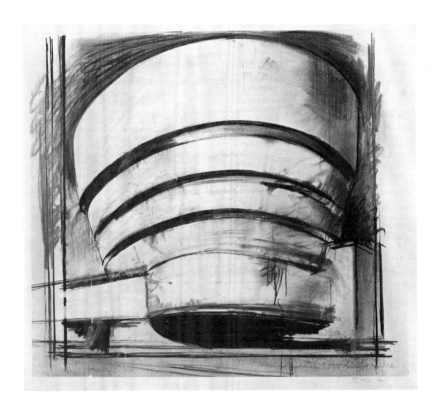

BELOW: DAVID HOCKNEY. *LILA DE NOBILI*. 1973. CRAYON, 25 1/2 X 19 3/4" (64.8 X 50.2 CM). COLLECTION JOHN RICHARDSON, NEW YORK

DAVID HOCKNEY was born in 1937 in Bradford, England. He studied at Bradford College of Art from 1953 to 1957. A conscientious objector, Hockney worked in a hospital from 1957 to 1959 in lieu of entering military service. He studied at the Royal College of Art from 1959 to 1962. During this period Hockney won several graphic awards and traveled to New York and Berlin. In 1962 he taught at the Maidstone College of Art. The following year he had his first one-man exhibition at the Kasmin Gallery, London. He taught art in a number of U.S. colleges, including the University of Iowa (1964), University of Colorado (1965), University of California, Los Angeles (1966), and University of California, Berkeley (1967). He has also traveled extensively in both the U.S. and Europe. In 1970 a major exhibition of Hockney's work was organized in London and shown also in Hannover and Rotterdam.

Bibliography:

Baro, Gene. "David Hockney's Drawings," *Studio International,* May 1966, pp. 184-86.
Battye, John Christopher. "David Hockney," *Art and Artists,* April 1970, pp. 50-53.
Bonin, Wibke von. *David Hockney.* Catalog. Berlin: Galerie Mikro, 1968.
Glasebrook, Mark. *David Hockney Paintings, Prints, Drawings 1960-1970.* Catalog. London: The Whitechapel Art Gallery, 1970.
Restany, Pierre, and Spender, Stephen. *David Hockney: Paintings and Drawings.* Catalog. Paris: Musée des Arts Décoratifs, 1974.
Rothenstein, John. *Modern English Painters.* Vol. 3. New York: St. Martin's Press, 1974, pp. 221-31.

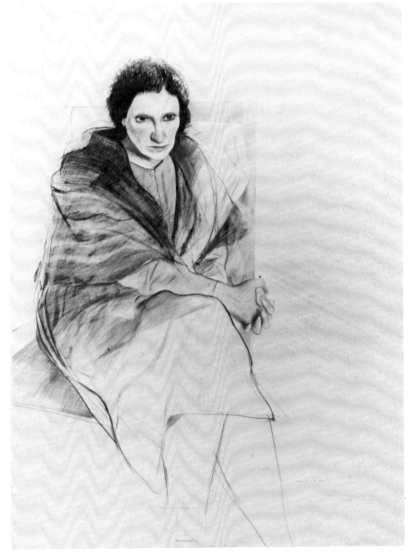

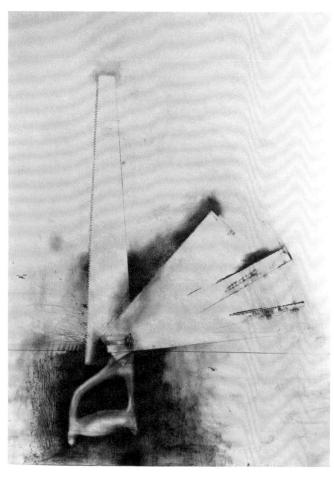

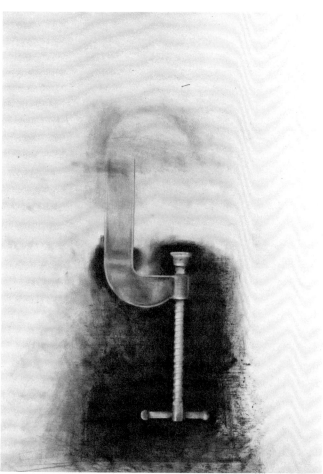

JIM DINE. UNTITLED TOOL SERIES (5-BLADED SAW, C CLAMP, OIL CAN, BRACE AND BIT, HOOF NIPPER, DRY-WALL HAMMER, AND PLIERS). 1973. EACH, CHARCOAL AND GRAPHITE, 25 5/8 X 19 7/8" (65.1 X 50.2 CM). LENT ANONYMOUSLY

JIM DINE was born in 1935 in Cincinnati, Ohio. In 1952 he attended evening classes at the Art Academy of Cincinnati, and in 1953-54 he was a student at the University of Cincinnati. He briefly attended the Boston Museum School before starting Ohio University, Athens, in 1955. After receiving a B.F.A. in 1958, he began working on an M.F.A. In 1958 and 1959 Dine lived and taught on Long Island; then from 1959 to 1961 he resided in New York, where he taught art. He was involved in the first "happenings" of 1959-60. His first one-man show was held at the Reuben Gallery, New York, in 1960. Dine won an award in 1964 from the Art Institute of Chicago. He taught at both Yale University and Oberlin College in 1965, at Cornell University in 1966-67, and was artist in residence at Dartmouth College in 1974. Dine lived in London from 1967 to 1970. He now lives in Vermont.

Bibliography:

Alloway, Lawrence. *American Pop Art.* Catalog. New York: Whitney Museum of American Art, 1974.
Calas, Nicolas. "Jim Dine, Tools and Myth," *Metro,* 1962, pp. 76-77.
Gordon, John, and Padgett, Ron. *Jim Dine.* Catalog. New York: Whitney Museum of American Art, 1970.
Kozloff, Max. "The Honest Elusiveness of James Dine," *Artforum,* December 1964, pp. 36-40.
Russell, John; Schmied, Wieland; and Towle, Tony. *Jim Dine: Complete Graphics.* Catalog. Hannover: Kestner-Gesellschaft, 1970.
Smith, Brydon. "Jim Dine: Magic and Reality," *Canadian Art.* January 1966, pp. 30-34.
Solomon, Alan R. "Jim Dine and the Psychology of the New Art," *Art International,* October 1964, pp. 52-56.

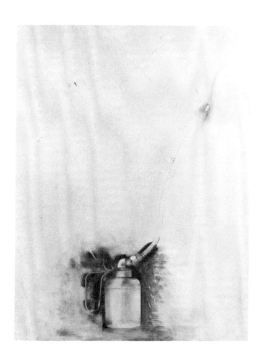

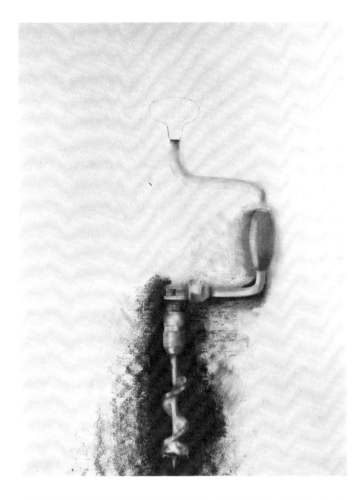

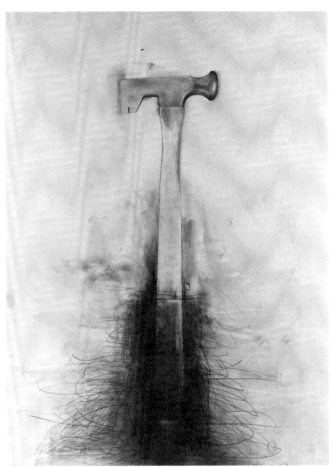

juxtaposes banality and parody of ordinary "good taste" on a Pop level with a nostalgia for the English tradition of beautiful draftsmanship and lyrical color.

Both artists have perhaps been stimulated to think of drawing in more traditional terms through early and intensive involvement in traditional etching techniques—especially, again, the British tradition with all it implies, for both artists have worked extensively in England. Originally involved more with a kind of literal "cool" imagery, each has now marked out a particular place for himself in relation to traditional drawing. Quoting and extending boldly, they experience no need for the more radical reappraisals of their Pop colleagues.

DURING the sixties the drawing as a preliminary step to work in another medium assumed a vital role. As sculptors began to have their works fabricated by industrial craftsmen outside the old foundry tradition, it became important for the artist to provide first, for himself, a visualization of what the work would look like and then, for the fabricator, a sketch or diagram with measurements and instructions.

In the mid-fifties Johns's initiating of a rationalized art-making process and of an object-type image had become the base upon which a broader rationalization of process and image was built. Stella's deductive structures and shaped canvases pointed the way to early Minimal art, the art of objects which came to dominate the sixties.

Minimal artists and sculptors such as Donald Judd, Dan Flavin, and Robert Morris started with these "cutlery drawings" out of direct necessity, ending several years later by appreciating the activity of drawing for its own sake. It was the particular gift of artists like Flavin to restore to contemporary sensibility an initial sense of the drawing as conceptual, in the sense that it represented, independent of conventional aesthetic notions, an act of ideation on the part of the artist. Later it became clear that this was the nucleus around which a new interest in drawing had taken form. Study drawings such as Larry Poons's became underground cult objects. Drawings which artists had kept simply for their own information were collected, first by trading among the artists themselves and later by fledgling collectors.

For some of these artists drawing became an economic necessity, enabling them to continue to work on more ambitious projects. Environmental artists like Robert Smithson drew either to visualize work that could not be executed because of its ambitions or else to bring to manageable scale a work of monumental proportions. At times, *ex post facto* drawings were made to provide a record of works executed in distant locations.

Christo's drawing belongs to this category. He is one of the few environmental sculptors to have a full range of traditional, academic drawing techniques available. His facility is such that it puts his drawings in "the grand tradition." Their essence lies in the drawing as a traditional conceptual structure; they are a type of *modello*.

With the projects for environmental art in the landscape, and the drawings for them, another species of drawing emerged. This was drawing in the land itself: Michael Heizer's drawings in the Nevada desert, the works of Oppenheim, the linear traces left behind by Richard Long on his walks through the landscape. Drawing became a marking on the world itself, totally environmental.

Precedents exist—cave drawings, drawings scratched in the ground during primitive ceremonies. The most striking parallel, however, is found on the desert plains of Peru, where a series of ancient delineations of animal and abstract figures—on so gigantic a scale that their total configuration can be seen only from the air—remain as evidence of an incredible conceptual enterprise.

With the sixties and the general prosperity of the decade, an extraordinary market for art emerged. Art became a commercially viable commodity, and

OPPOSITE, ABOVE: JEAN TINGUELY. COLORED STUDY FOR SCULPTURE FOR MONTREAL WORLD'S FAIR. 1967. COLORED PENCIL, 13 3/4 X 51 1/4" (34.9 X 130.1 CM). COLLECTION HELMUT KLINKER, BOCHUM, WEST GERMANY

JEAN TINGUELY was born in 1925 in Fribourg, Switzerland. In 1928 his family moved to Basel, and from 1941 to 1945 he attended the Basel School of Fine Arts. In 1945 Tinguely made his first kinetic constructions in wire, metal, wood, and paper. In 1951 he moved to Paris, where his first one-man show was held at the Galerie Arnaud in 1954. Tinguely's first U.S. one-man exhibition took place at Staempfli Gallery, New York, in 1960. That same year he created *Homage to New York*, a self-destroying machine, in The Museum of Modern Art Sculpture Garden. In 1962 he participated in theatrical events with Robert Rauschenberg and the Merce Cunningham Dance Company in New York. He had an exhibition of his prints in 1975 at The Museum of Modern Art. Tinguely lives and works in Switzerland.

Bibliography:

Boudaille, Georges. "Jean Tinguely," *Cimaise,* July-August 1962, pp. 52-59.
Cassou, Jean; Hultén, K. G. Pontus; and Hunter, Sam. *2 Kinetic Sculptors: Nicolas Schöffer and Jean Tinguely.* Catalog. New York: The Jewish Museum, 1965.
Cianetti, Franco. "Tinguely," *Du,* April 1964, pp. 27-43.
Graf, U. "Tinguely Interview: Ein Gesprach mit dem schweizer Maschinenkunstler," *Werk,* March 1970, pp. 184-86.
Hultén, K. G. Pontus. *Jean Tinguely: "Méta."* Frankfurt am Main: Verlag Ullstein GmbH, 1972.
Jean Tinguely. Catalog. Amsterdam: Stedelijk Museum, 1973.
Reutersward, Oscar, and Fahlström, Oyvind. "Jean Tinguely: Luftleken och krosshammaren," *Konstrevy,* December 1960, pp. 192-96.
Tomkins, Calvin. "A Profile of Jean Tinguely: Beyond the Machine," *New Yorker,* February 10, 1962, pp. 44-93. Reprinted in somewhat altered form in *The Bride and the Bachelors: The Heretical Courtship in Modern Art.* New York: Viking Press, 1965, pp. 145-88.

MARK DI SUVERO was born in Shanghai, China, in 1933 and emigrated to the U.S. with his family in 1941. He attended classes at San Francisco City College and the University of California, Berkeley, where he studied philosophy. In 1957 di Suvero moved to New York. Three years later he was severely injured in an elevator accident. Di Suvero's first one-man show took place that year in the Green Gallery, New York. In the same year, the scale of his sculpture greatly increased. In 1963 di Suvero began to make his large constructions out of wood and steel. In 1971 di Suvero moved to Europe in protest against American involvement in Vietnam. A major exhibition of his work was held at the Stedelijk van Abbemuseum in Eindhoven, the Netherlands, in 1972 and later was shown in Duisberg, West Germany. Five of his large sculptures appeared in exhibition in the Tuileries, Paris, in the spring of 1975, and later in the year the Whitney Museum of American Art, New York, mounted a large exhibition of his sculptures at the museum and in fifteen sites around New York City.

Bibliography:

Baker, Elizabeth C. "Mark di Suvero's Burgundian Season," *Art in America,* May 1974, pp. 59-63.
Geist, Sidney. "New Sculptor: Mark di Suvero," *Arts Magazine,* December 1960, pp. 40-43.
Kozloff, Max. "Mark di Suvero: Leviathan," *Artforum,* Summer 1967, pp. 41-46.
Monte, James. *Mark di Suvero.* Catalog. New York: Whitney Museum of American Art, 1975.
Ratcliff, Carter. "Mark di Suvero," *Artforum,* November 1972, pp. 34-42.
Rosenstein, Harris. "Di Suvero: The Pressures of Reality," *Art News,* February 1967, pp. 36-39, 63-65.

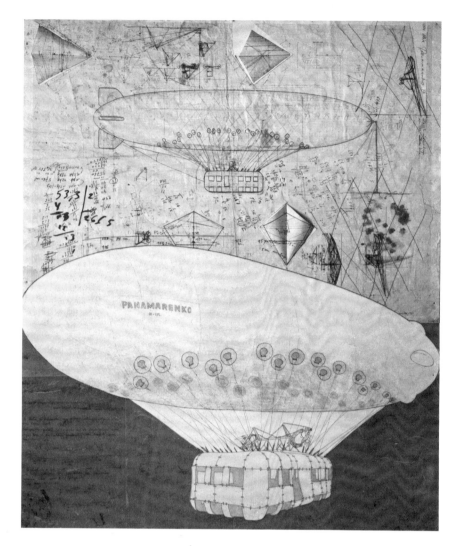

PANAMARENKO. *DIRIGIBLE.* 1972. PEN AND INK, COLORED PENCIL, AND COLLAGE ON GRAPH PAPER, 37 5/8 X 32 1/8" (95.5 X 81.5 CM). COLLECTION MIA AND MARTIN VISSER, BERGEYK, THE NETHERLANDS

PANAMARENKO was born in 1940 in Antwerp, Belgium, and studied at the Académie des Beaux-Arts, Antwerp. His first one-man exhibition was held at the C.A.W., Antwerp, in 1963. His pseudonym is derived from his admiration for Pan American Airline and Russian aviators. Most of his art also reveals his fascination with the field of aviation and the phenomenon of natural flight.

Bibliography:

Baudson, M., and Gevaert, Y. "Aspects of the Avant-garde in Belgium," *Studio International,* October 1974, pp. 142-43.
Lebeer, I. "Panamarenko," *Studio International,* October 1974, pp. 134-35.
Panamarenko: Automobile und Flugmaschinen. Catalog. Lucerne: Kunstmuseum, 1972.
Thwaites, John Anthony. "Cologne," *Art and Artists,* May 1972, p. 52.
When Attitudes Become Form. Catalog. London: Institute of Contemporary Arts, 1969.

OYVIND FAHLSTRÖM. *NOTES FOR SITTING . . . SIX MONTHS LATER.* 1962. PEN AND INK AND WATERCOLOR IN TWO PARTS; THIS PART (B), 8 5/8 X 11 5/8" (21.9 X 29.5 CM). COLLECTION JASPER JOHNS, NEW YORK

OYVIND FAHLSTRÖM was born in 1928 in São Paulo, Brazil, to Norwegian and Swedish parents. In 1939 the family moved to Stockholm. Fahlström studied art history and archaeology at the University of Stockholm from 1949 to 1952. His interests included writing as well, and during the 1950s he wrote plays, concrete poetry, and art criticism. His first one-man exhibition was held in 1953 at the Galleria Numero, Florence. He came to New York in 1961 on a scholarship from the Scandinavian-American Foundation and began his Sitting series in that year. During the early 1960s Fahlström staged "happenings" at the Moderna Museet, Stockholm. He participated in the Experiments in Art and Technology (E.A.T.) in New York in 1966.

Bibliography:

Adrian, Dennis. "Fahlström: The Three Faces of Oyv," *Artforum,* April 1967, pp. 47-48.
Ekbom, Torsten. "Oyvind Fahlström: Models of Shattered Reality," *Art International,* Summer 1966, pp. 49-52.
Fahlström. Catalog. Munich: Galerie Buchholz, 1974.
Gablik, Suzi. "Fahlström: A Place for Everything," *Art News,* Summer 1966, pp. 38-41, 61-64.
Jouffroy, Alain. "L'Actualisme de Fahlström," *Pentacle.* Catalog. Paris: Musée des Arts Décoratifs, 1968.

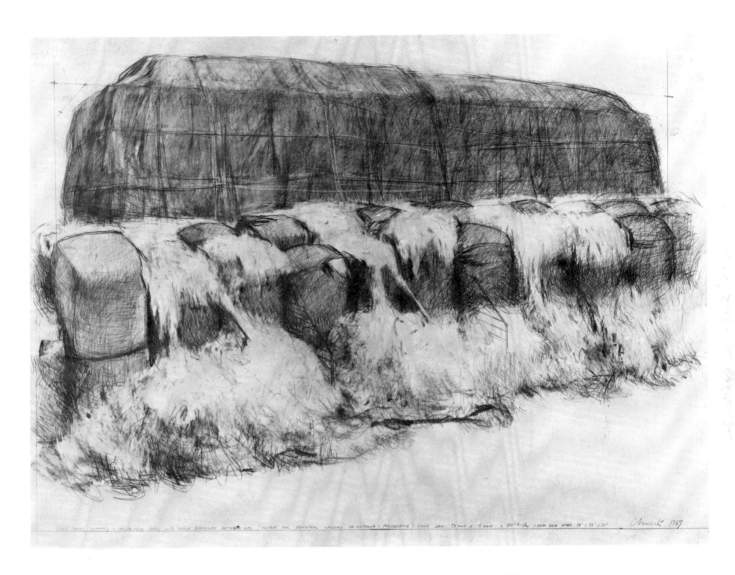

CHRISTO. *WRAPPED WOOL BALES: PROJECT FOR THE NATIONAL GALLERY OF VICTORIA, MEL-BOURNE.* 1969. GRAPHITE AND COLORED PENCIL, CHARCOAL, 36 1/2 X 49 3/4" (92.7 X 126.3 CM). COLLECTION ANDREAS VOWINCKEL, COLOGNE

CHRISTO was born Christo Javacheff in 1935 in Gabrovo, Bulgaria. He received his first training in art at the Fine Arts Academy in Sofia from 1952 to 1956. In 1956 he studied stage design at the Burian Theater in Prague. The following year he attended the Vienna Fine Arts Academy for one semester, then made a brief trip to Florence. He spent several months in Geneva in 1958. In March of that year he established residence in Paris and became associated with the Nouveaux Réalistes. During this time he made his first wrapped objects. Christo had his first one-man exhibi-tion at Galerie Haro Lauhus, Cologne, in 1961. In 1961 he also made his first plan for a wrapped building, and in 1969 he actually wrapped the coast near Sydney, Australia. Since 1964, the artist has resided in New York City.

Bibliography:

Alloway, Lawrence. *Christo.* New York: Harry N. Abrams, 1969.

Bourdon, David. *Christo.* New York: Harry N. Abrams, 1971.

Bourdon, David, and Hahn, Otto. "Christo," *Art and Artists,* October 1966, pp. 50-53.

Hahn, Otto. "Christo's Packages," *Art International,* April 1965, pp. 25-28.

Marck, Jan van der. *Christo.* Catalog. Melbourne: National Gallery of Victoria, 1969.

Marck, Jan van der. "The Valley Curtain," *Art in America,* May-June 1972, pp. 54-67.

Prokopoff, Stephen S. "Christo," *Art and Artists,* April 1969, pp. 12-17.

LARRY POONS. UNTITLED. 1962. PENCIL ON GRAPH PAPER, 17 X 22" (43.2 X 55.9 CM). NATIONAL GALLERY OF ART, WASHINGTON, D.C., ANDREW W. MELLON PURCHASE FUND.

LARRY POONS was born in Tokyo in 1937, and the following year his family moved to New York. Poons studied music at the New England Conservatory of Music, Boston, from 1955 to 1957. In 1957 he entered the Boston Museum School, where he studied art for six months. He began painting professionally in 1957. His first one-man show was held at Green Gallery, New York, in 1963. In 1967 Poons was a visiting teacher at the New York Studio School. His work has been shown in numerous exhibitions in museums and galleries.

Bibliography:

Champa, Kermit S. "New Paintings by Larry Poons," *Artforum,* Summer 1968, pp. 39-42.
Coplans, John. "Larry Poons," *Artforum,* June 1965, pp. 33-35.
Kozloff, Max. "Larry Poons," *Artforum,* April 1965, pp. 26-29.
Lippard, Lucy R. "Larry Poons: The Illusion of Disorder," *Art International,* April 1967, pp. 22-26.
Tillim, Sidney. "Larry Poons: The Dotted Line," *Arts Magazine,* February 1965, pp. 16-21.
Tucker, Marcia. *The Structure of Color.* Catalog. New York: Whitney Museum of American Art, 1971.
Wood, James N. *Six Painters.* Catalog. Buffalo: Fine Arts Academy, Albright-Knox Art Gallery, 1971.

BRIDGET RILEY. UNTITLED. 1965. GOUACHE AND PENCIL ON GRAPH PAPER, 13 1/2 X 17 1/2" (34.3 X 44.5 CM). COLLECTION JASPER JOHNS, NEW YORK

BRIDGET RILEY was born in 1931 in London. From 1939 to 1945 she and her mother lived with her aunt in Cornwall while her father was in the army. Her aunt encouraged her interest in art. Riley studied at Cheltenham Ladies' College (1946-48), Goldsmith's College of Art (1949-52), and The Royal College of Art (1952-55). Between 1956 and 1959 she discontinued painting and worked in an advertising agency. Her first one-woman exhibition was held at Gallery One, London, in 1962. She has won several awards and been included in numerous international exhibitions.

Bibliography:

Kudielka, Robert. "Jenseits von Op-Art: Bridget Riley im Gesprach," *Das Kunstwerk,* December 1968-January 1969, pp. 15-25.
Licht, Jennifer. *Bridget Riley Drawings.* Catalog. New York: The Museum of Modern Art, 1966.
Robertson, Bryan. *Bridget Riley.* Catalog. Bern: Kunsthalle, 1971.
Robertson, Bryan. *Bridget Riley: Paintings and Drawings 1951-71.* Catalog. London: The Hayward Gallery, 1971.
Sausmarez, Maurice de. *Bridget Riley.* Greenwich, Conn.: New York Graphic Society, 1970.
Sausmarez, Maurice de. "Bridget Riley and Maurice de Sausmarez: A Conversation," *Art International,* April 1967, pp. 37-41.

DAN FLAVIN. *THE MONUMENT TO V. TATLIN XI OF AUG. 18, 1964.* 1964. YELLOW OCHER AND WHITE PENCIL ON BLACK PAPER, 9 3/4 X 12 3/4" (24.8 X 32.4 CM). THE ST. LOUIS ART MUSEUM, FUNDS DONATED BY THE CONTEMPORARY ART SOCIETY

DAN FLAVIN was born in New York City in 1933. He was interested in art as a young boy. A student at Cathedral College in Brooklyn from 1947 to 1952, he entered the U.S. Air Force Meteorological Technician Training School upon leaving school. During his service in Korea, Flavin helped organize a figure drawing class. In 1956 he studied art history at the New School for Social Research, New York, and continued in art history at Columbia University from 1957 to 1959. His first one-man show was held at the Judson Gallery, New York, in 1961. Since the early 1960s Flavin has created sculptures out of fluorescent lights. He was the recipient of an award in 1964 from the William and Noma Copley Foundation and from the National Foundation of Arts and Humanities in 1966. He lectured at the University of North Carolina, Greensboro, during the spring of 1967. Flavin currently resides in Garrison, N.Y.

Bibliography:

Burnham, Jack. "Dan Flavin: Retrospective in Ottawa," *Artforum*, December 1969, pp. 48-55.
Flavin, Dan. "…in Daylight or Cool White," *Artforum*, December 1965, pp. 20-24.
Flavin, Dan. "Some Other Comments…," *Artforum*, December 1967, pp. 20-25.
Flavin, Dan. "Some Remarks…," *Artforum*, December 1966, pp. 27-29.
Flavin, Dan, and Rauh, Emily S. *Diagrams and Drawings 1963-1972.* Catalog. The St. Louis Art Museum, 1973.
Plagens, Peter. "Rays of Hope, Particles of Doubt," *Artforum*, June 1973, pp. 33-35.
Smith, Brydon. *Etc. from Dan Flavin.* Catalog. Ottawa: The National Gallery of Canada, 1969.

DONALD JUDD. UNTITLED. 1966. FELT PEN ON YEL-
LOW PAPER, 17 1/4 X 22 1/8" (43.8 X 56.2 CM). THE
MUSEUM OF MODERN ART, NEW YORK, PURCHASE

DONALD JUDD was born in Excelsior Springs, Mo., in 1928. Upon graduation from high school, he enlisted in the U.S. Army Corps of Engineers and was in Korea in 1946–47. When he returned he studied in New York and in 1953 graduated from Columbia with a B.S. in philosophy. He later continued at Columbia in a master's program in art history, studying with Rudolf Wittkower and Meyer Schapiro. From 1959 to 1965 Judd was active as an art critic. In 1965 he traveled to Sweden on a grant from the Swedish Institute. He was visiting artist at Dartmouth College in the summer of 1966 and taught a sculpture seminar at Yale University in 1967. He resides in Marfa, Tex., and New York.

Bibliography:

Agee, William. *Donald Judd.* Catalog. New York: Whitney
 Museum of American Art, 1968.
"The Artist and Politics: A Symposium," *Artforum,*
 September 1970, pp. 36-37.
Baker, Elizabeth C. "Judd the Obscure," *Art News,*
 April 1968, pp. 44-45.
Coplans, John. "An Interview with Don Judd," *Artforum,*
 June 1971, pp. 40-50.
Friedman, Martin. "The Nart-Art of Donald Judd," *Art
 News,* February 1967, pp. 59-62.
Glaser, Bruce. "Questions to Stella and Judd," *Art News,*
 September 1966, pp. 55-61.
Goldin, Amy. "The Antihierarchical American," *Art News,*
 September 1967, pp. 48-50.
Krauss, Rosalind. "Allusion and Illusion in Donald Judd,"
 Artforum, May 1966, pp. 24-26.
Smith, Brydon. *Donald Judd.* Catalog. Ottawa: The
 National Gallery of Canada, 1975.

FRED SANDBACK. *STUDY FOR SCULPTURE.* 1971.
PENCIL AND WHITE INK ON YELLOW PAPER, 8 X
9 1/8" (20.3 X 23.2 CM). THE MUSEUM OF MODERN
ART, NEW YORK, THE HENRY PEARLMAN FOUNDA-
TION AND NATIONAL ENDOWMENT FOR THE ARTS
MATCHING PURCHASE FUND

FRED SANDBACK was born in 1943 in Bronxville, N.Y. He studied at Williston Academy, Easthampton, Mass., from 1957 to 1961 and at the Theodor-Heuss-Gymnasium, Heilbronn, Germany, in 1962. He received a degree from Yale University in 1966 and attended its School of Art and Architecture from 1966 to 1969. Two of his works were included in the exhibition *New Media: New Methods* circulated by The Museum of Modern Art through the U.S. and Canada in 1969-70. Sandback's first one-man exhibition was held at the Galerie Konrad Fischer, Düsseldorf, in 1969. His work was shown at the Kunstraum, Munich, in 1975.

Bibliography:

Hutchinson, Peter. "The Perception of Illusion: Object
 and Environment," *Arts Magazine,* April 1968, pp. 13-15.
Kern, Hermann. *Fred Sandback.* Catalog. Munich: Kunst-
 raum, 1975.
"Snap-on Structures," *Art in America,* July-August 1968,
 pp. 56-57.
When Attitudes Become Form. Catalog. London: Institute
 of Contemporary Arts, 1969.

BRICE MARDEN. UNTITLED. 1971. GRAPHITE AND WAX, 21 3/8 X 14" (54.3 X 35.6 CM). COLLECTION JACK KLEIN, NEW YORK

BRICE MARDEN was born in Bronxville, N.Y., in 1938. He studied at Florida Southern College in 1957-58 and received a B.F.A. in 1961 from Boston University School of Fine and Applied Arts. He spent that summer at the Yale Summer School of Music and Art, Norfolk, Conn., and in 1963 received an M.F.A. from Yale University School of Art and Architecture. In the fall of 1963 Marden came to New York City and was hired as a guard at The Jewish Museum, where he saw the work of Jasper Johns. His first one-man exhibition was held in 1964 at the Wilcox Gallery, Swarthmore College, Pa. In recent years he has taught painting at the School of Visual Arts, New York, and the Skowhegan School of Painting and Sculpture, Maine. His work was shown in a one-man exhibition at the Solomon R. Guggenheim Museum, New York, in 1975.

Bibliography:

Ashbery, John. "Grey Eminence," *Art News*, March 1973, pp. 26-27, 64-66.
Gilbert-Rolfe, Jeremy. "Brice Marden's Painting," *Artforum*, October 1974, pp. 30-38.
Licht, Jennifer. *Eight Contemporary Artists*. Catalog. New York: The Museum of Modern Art, 1974.
Rosenstein, Harris. "Total and Complex," *Art News*, May 1967, pp. 52-54.
Shearer, Linda. *Brice Marden*. Catalog. New York: The Solomon R. Guggenheim Museum, 1975.
Smith, Roberta P. "Brice Marden's Painting," *Arts Magazine*, May-June 1973, pp. 36-41.

ROBERT RYMAN. *STRETCHED DRAWING*. 1963. PENCIL ON STRETCHED CANVAS, 14 1/2 X 14 1/2" (36.8 X 36.8 CM). COLLECTION OF THE ARTIST

ROBERT RYMAN was born in 1930 in Nashville, Tenn. He attended the Tennessee Polytechnic Institute, Cookville (1948-49), and the Peabody College for Teachers, Nashville (1949-50). Ryman served in the U.S. Army from 1950 to 1952. Upon being discharged he moved to New York and began to paint in 1954. In 1967 his first one-man exhibition was held at Bianchini Gallery, New York. In 1972 The Solomon R. Guggenheim Museum organized a one-man exhibition of his work. He has had a number of one-man shows in Europe.

Bibliography:

Pincus-Witten, Robert. "Ryman, Marden, and Manzoni: Theory, Sensibility, Mediation," *Artforum* June 1972, pp. 50-53.
Ratcliff, Carter. "Robert Ryman's Double Positive," *Art News*, March 1971, pp. 54-56, 71-72.
Reise, Barbara. "Robert Ryman: Unfinished I," *Studio International*, February 1974, pp. 76-80.
Reise, Barbara. "Robert Ryman: Unfinished II," *Studio International*, March 1974, pp. 122-28.
Robert Ryman. Catalog. Amsterdam: Stedelijk Museum, 1974.
Tuchman, Phyllis. "An Interview with Robert Ryman," *Artforum*, May 1971, pp. 46-53.
Waldman, Diane. *Robert Ryman*. Catalog. New York: The Solomon R. Guggenheim Museum, 1972.

ELLSWORTH KELLY. CURVE = RADIUS OF TEN FEET. 1974. PENCIL, 36 X 36" (91.4 X 91.4 CM). COLLECTION MRS. BAGLEY WRIGHT, SEATTLE

ELLSWORTH KELLY was born in 1923 in Newburgh, N.Y. He studied art at Pratt Institute, Brooklyn, from 1941 to 1943. From 1943 to 1945 Kelly served in the Army Engineers Camouflage Battalion in England and France. After the war he resumed his art training, attending the Boston Museum School from 1946 to 1948. He then moved to Paris and enrolled at the Ecole des Beaux-Arts. Kelly had his first one-man show at Galerie Arnaud, Paris, in 1951. He returned to New York in 1954 and became friendly with Agnes Martin and Robert Indiana. His first one-man show in New York was at the Betty Parsons Gallery in 1956. By 1960 he was an established artist in New York. Kelly had a major one-man exhibition at The Museum of Modern Art, New York, in 1973.

Bibliography:

Ashton, Dore. "Kelly's Unique Spatial Experiences," *Studio International,* July 1965, pp. 40-43.
Coplans, John. *Ellsworth Kelly.* New York: Harry N. Abrams, 1973.
Geldzahler, Henry. "Interview with Ellsworth Kelly," *Art International,* February 1964, pp. 47-48.
Goossen, E. C. *Ellsworth Kelly.* New York: The Museum of Modern Art, 1973. Published on the occasion of an exhibition, 1973.
Rose, Barbara. "The Sculpture of Ellsworth Kelly," *Artforum,* June 1967, pp. 51-55.
Waldman, Diane. *Ellsworth Kelly: Drawings, Collages, Prints.* Greenwich, Conn.: New York Graphic Society, 1971.

art—Environmental art, Minimal art, Conceptual art—took up a stance in reaction to the vulgarization of art by the marketplace, the sudden incursion of consumer civilization. Taste might be bought and sold; but, the artist in effect declared, art could not. His reaction was to "dematerialize" art—to make art that was impossible to collect because of the conditions of its creation, to create art of minimum visual appeal (in retrospect, only in contrast to what had gone before), or an art based only on idea.

From the point of view of the dynamics of art itself, however, an inner mechanism was more important. The crisis of illusionism was being expressed again in relation to art as object. Once again there occurred a change in the aspect of art, and again the sources informing that change were multiple; the rationalization of art which had been initiated with Johns continued, but under a more literal series of conditions. The tactile object in the Renaissance window had been identified by Jasper Johns with canvas itself. Frank Stella, following clues supplied by Johns, made paintings whose inner structure was deduced from the edge of the canvas itself—an echo of the outer shape. He moved gradually into shaped canvases based on geometric figures that generated complex internal structures. To Stella the important point was that the structure be nonrelational; relational meant "balance. You do something in one corner and balance it with something in the other." The idea was to avoid "compositional effects," to have a sense of wholeness. Stella wanted in a painting "only what was necessary to make a painting." He worked systematically and in numerically predetermined, closed series. His paintings were made on stretchers deeper than usual; they looked like objects. Stella says the idea was to stress the surface; painting is about surface. But he also said (in conversation with Donald Judd and critic Bruce Glaser), "Any painting is an object, and anyone who gets involved enough in this finally has to face up to the objectness of whatever it is that he is doing. He is making a thing...All I want anyone to get out of my paintings...is the fact that you can see the whole idea without any confusion....What you see is what you see."[38] The crisis was also stated in terms of still further reduced means. Stella was explicit in his wish to get the sentiment out of painting and outspoken against drawing in painting as handwriting—drawing as unnecessary to painting, complicating it and mitigating the quality of paint as paint.

For Donald Judd and Sol LeWitt—as for several others—the issue became one of making a work of art that was neither a painting nor a sculpture but simply a three-dimensional art work. Stella's ideas of wholeness and nonrelational structures were important, carried out literally, but Judd himself states the case against painting and sculpture as it appeared at that time in a seminal essay written in 1965, "Specific Objects":

The main thing wrong with painting is that it is a rectangular plane placed flat against the wall. A rectangle is a shape itself; it is obviously the whole shape; it determines and limits the arrangement of whatever is on or inside of it....

Except for a complete and unvaried field of color or marks, anything placed in a rectangle and on a plane suggests something in and on something else, something in its surround...Fields are also usually not limited, and they give the appearance of sections cut from something indefinitely larger.[39]

Judd goes on to say that "oil and canvas are familiar and, like the rectangular plane, have a certain quality and have limits. The quality is especially identified with art."

His objections are pointed: any painting, no matter how shallow the space or broad the field, will be illusionistic; paint itself is a material associated with art as illusionism. Art was to be totally new, divorced from illusionism. If "sculptural" it was to be divorced from the traditional relational construction of sculpture.

It was to be a whole, literal and singular in form, nonrelational, although it could be composed additively and/or serially of equal parts. For Robert Morris it also had to be neutral in color, since color was proper to painting.

ABOVE: FRANK STELLA. CATO MANOR. 1962. COLORED PENCIL, 12 X 10" (30.5 X 25.4 CM). COLLECTION MR. AND MRS. ROGER DAVIDSON, TORONTO

BELOW: FRANK STELLA. SHARPEVILLE. 1962. COLORED PENCIL, 12 X 10" (30.5 X 25.4 CM). COLLECTION MR. AND MRS. LESTER TRIMBLE, NEW YORK

OPPOSITE, ABOVE: FRANK STELLA. LES INDES GALANTES. 1962. COLORED PENCIL, 10 X 12" (25.4 X 30.5 CM). COLLECTION JONATHAN D. SCULL, NEW YORK

OPPOSITE, BELOW: FRANK STELLA. FICKLE FAY CREEP. 1962. COLORED PENCIL, 10 X 12" (25.4 X 30.5 CM). HARRY N. ABRAMS FAMILY COLLECTION, NEW YORK

FRANK STELLA was born in 1936 in Malden, Mass. His childhood was spent in Malden and nearby Melrose. After studying painting with Patrick Morgan at Phillips Academy, Andover, Mass., he went to Princeton University where he studied with William C. Seitz and Stephen Greene, and received a B.A. in 1958. After graduation Stella moved to New York, and in 1959-60 he worked on his series of Black paintings. In 1959 he was included in the exhibition *16 Americans* at The Museum of Modern Art. Stella made his first shaped canvases in 1960, and the same year he had his first one-man show at Leo Castelli Gallery, New York. In 1962 he began a series of Concentric Squares and Mitered Mazes, which continued until 1963. He was included in the 1964 Venice Biennale and won first prize in the 1967 International Biennale Exhibition of Paintings in Tokyo. Stella had a major one-man exhibition at The Museum of Modern Art in 1970. He lives and works in New York City.

Bibliography:

Fried, Michael. *Frank Stella: An Exhibition of Recent Paintings.* Catalog. Pasadena Art Museum, 1966.
Fried, Michael. *Three American Painters: Kenneth Noland, Jules Olitski, Frank Stella.* Catalog. Cambridge: The Fogg Art Museum, Harvard University, 1965.
Glaser, Bruce. "Questions to Stella and Judd," *Art News,* September 1966, pp. 55-61.
Lebensztejn, Jean-Claude. "57 Steps to Hyena Stomp," *Art News,* September 1972, pp. 60-67.
Rosenblum, Robert. *Frank Stella.* Baltimore: Penguin Books, 1971.
Rosenblum, Robert. "Frank Stella: Five Years of Variations on an Irreducible Theme," *Artforum,* March 1965, pp. 21-25.
Rubin, William. *Frank Stella.* New York: The Museum of Modern Art, 1970. Published on the occasion of an exhibition.
Seitz, William C. *Recent Paintings by Frank Stella.* Catalog. Waltham, Mass.: Rose Art Museum, Brandeis University, 1969.

The reductive principle, insofar as it implied impersonal surface, was already operational in the work of Pop artists such as Warhol and Lichtenstein.

At the same time, painters such as Robert Ryman were trying to escape the objectness of painting—its illusionism as stated by Judd in terms of its being one thing placed on another—by narrowing the stretcher and making the painting as flat to the wall as possible, and by eliminating color in favor of modulation of surface through paint facture.

Early Minimal work was projected according to simple systems with a basis in geometry. The grid was implied in Cubism, intrinsic in Pollock, a basis for some of Johns's early work, and was explicit in the work of early rationalist painters such as Agnes Martin, whose pencil grids on painted canvas played a key role in the projection of the grid image which came to dominate the sixties. Projected into three dimensions, the grid became the key to the rational placement of units in Minimal art.

The importance of drawing to the art of the sixties in one practical sense has already been noted. As Robert Morris, originally involved with Minimal and then with "anti-formal" work, has noted, the connection between the two-dimensional and three-dimensional aspects of Minimal art was more causal than the simple notation of an idea might indicate:

Minimal art's diagrammatic aspect was derived from plans generated by drawings on flat pages. Most Minimal art was an art of flat surfaces in space. At best an object can be permuted in its positions or parts and as such can be rotated on its own dense axis....

Perhaps the most compelling aspect of Minimalism was that it was the only art of objects (aside from the obvious example of architecture) which ever attempted to mediate between the notational knowledge of flat concerns (Systems, the diagrammatic, the logically constructed and placed, the preconceived) and the concerns of objects (the relativity of perception in depth). But mediation is a delicate and frequently brief state of affairs. Work succeeding the Minimal which had an increased involvement with information and logical orderings moved ever more into the flat modes—whether on the wall or floor. It seems that the physical density and autonomy of objects becomes compromised when ordered by more than the simplest of systems.[40]

THUS the projection of drawing as the major two-dimensional work of the late sixties was established not as a function of the "failure" of painting but as a function of the nature of the discipline of drawing. Sol LeWitt had begun as a Minimalist, constructing sculpture out of rationalized modular components arranged according to simple systems. A 1966 work is titled *Modular Structure* and is a simple three-dimensional grid; a 1967 work is more complex—*3-Part Variations on 3 Different Kinds of Cubes.* The three different kinds of cubes are: completely enclosed, open at two sides, open at one side. They are stacked one on the other, in all possible permutations of stacks and in all possible permutations of axial rotation. Drawings exist for the permutations of most of these sculptures.

But LeWitt had even earlier grown cool to the idea of a reductive process whose only goal could be irreducible objects. And by 1967 he had already become involved in Conceptual art. Lawrence Alloway suggests Ad Reinhardt as one influence, Duchamp as another, and an essay—"Concept Art," by Henry Flynt, "which could have been available" to LeWitt—as another.[41] But what interests LeWitt more than anything else is the multiplicity of things, especially the multiplicity of things that can be generated by a simple idea. A simple modular method had been part of his making of sculpture; system became the concept which generated his drawings as well. The grid transferred to the wall became the basis for a virtually infinite number of variations —direct variations on the grid itself, in black and white and color, and, slightly later, figurations which are proposed on the base of an assumed underlying grid.

A recurrent theme in LeWitt's discussions with Judd and other artists of the

AGNES MARTIN. *STONE.* 1964. PENCIL, PEN AND INK, 11 X 11" (27.9 X 27.9 CM). THE MUSEUM OF MODERN ART, NEW YORK, EUGENE AND CLARE THAW FUND

AGNES MARTIN was born in 1912 in Maklin, Saskatchewan, Canada. Her father died when she was very young and her family moved to Vancouver. Martin came to the U.S. in the early 1930s and became a U.S. citizen in 1940. She attended Teachers College, Columbia University, New York, from 1941 to 1954 and received her B.S. and M.A. While in New York she decided to become an artist. After graduation she moved to Albuquerque, where she taught at the University of New Mexico. She moved to Taos in 1956 and met Betty Parsons, who supported her artistic efforts. In 1957 Martin moved back to New York and settled on Coenties Slip, near Ellsworth Kelly and Ad Reinhardt. Her first one-woman show took place at the Betty Parsons Gallery the next year. In 1967, after Reinhardt's death, she left New York abruptly for Cuba, N. Mex. She gave up art for some years, resuming work in 1974. She had an exhibition of eight of her 1974 paintings at Pace Gallery, New York, in 1975.

Bibliography:

Alloway, Lawrence. "Agnes Martin," *Artforum,* April 1973, pp. 32-36.
Alloway, Lawrence. "Formlessness Breaking Down Form: The Paintings of Agnes Martin," *Studio International,* February 1973, pp. 61-65.
Alloway, Lawrence, and Wilson, Ann. *Agnes Martin.* Catalog. Philadelphia: Institute of Contemporary Art, University of Pennsylvania, 1973.
Borden, Lizzie. "Early Work," *Artforum,* April 1973, pp. 39-44.
Gula, Kasha. "Agnes Martin at Pace," *Art in America,* May-June 1975, pp. 85-86.
Options and Alternatives: Some Directions in Recent Art. Catalog. New Haven: Yale University Art Gallery, 1973.
Wilson, Ann. "Linear Webs," *Art and Artists,* October 1966, pp. 46-49.

Stone

wood

AGNES MARTIN. *WOOD*. 1964. PEN AND INK, 11 X 10 7/8" (27.9 X 27.6 CM). THE MUSEUM OF MODERN ART, NEW YORK, EUGENE AND CLARE THAW FUND

FOLLOWING PAGE: SOL LeWITT. *STRAIGHT LINES IN FOUR DIRECTIONS SUPERIMPOSED*. 1969. GRAPHITE ON WHITE WALL, SIZE VARIABLE; INSTALLATION 12' X 26' 9" X 1/2" (366 X 822.9 X 1.3 CM). THE MUSEUM OF MODERN ART, NEW YORK, PURCHASE. DRAWN BY KAZUKO MIYAMOTO, STEPHEN STAVRIS, JO WATANABE, AND QUIQUI WATANABE, 1974. IN FOREGROUND, SCULPTURE BY RICHARD SERRA

SOL LeWITT was born in 1928 in Hartford, Conn. He received a B.F.A. from Syracuse University in 1949. In 1951-52 LeWitt served in the U.S. Army in Japan and Korea. He was an instructor at The Museum of Modern Art school, New York, from 1964 through 1967. His first one-man exhibition was held at the Daniels Gallery, New York, in 1965. His first wall drawing was created at the Paula Cooper Gallery, New York, in October 1968. LeWitt has taught at several schools, including Cooper Union, New York (1967-68), School of Visual Arts, New York (1969-70), and New York University (1969-70). A major one-man show was held at the Gemeentemuseum, The Hague, in 1970. LeWitt currently lives and works in New York.

Bibliography:

Alloway, Lawrence. "Sol LeWitt: Modules, Walls, Books," *Artforum*, April 1975, pp. 38-43.
Celant, Germano. "LeWitt," *Casabella*, July 1972, pp. 38-42.
Chandler, John N. "Tony Smith and Sol LeWitt: Mutations and Permutations," *Art International*, September 1968, pp. 16-19.
LeWitt, Sol. "Paragraphs on Conceptual Art," *Artforum*, Summer 1967, pp. 79-83.
Lippard, Lucy R. "Sol LeWitt: Non-Visual Structures," *Artforum*, April 1967, pp. 42-48.
Pincus-Witten, Robert. "Sol LeWitt: Word Object," *Artforum*, February 1973, pp. 69-72.
Reise, Barbara. "Sol LeWitt Drawings 1968-69," *Studio International*, December 1969, pp. 222-25.
Wember, Paul. *Sol LeWitt: Sculptures and Wall Drawings*. Catalog. Krefeld: Museum Haus Lange, 1969.

sixties was that of a return to fundamentals. LeWitt had started out as a painter; his objection to painting was the same as Judd's: a painting is a three-dimensional object—so he began to make three-dimensional objects. But that did not solve the problem of how to make a two-dimensional work of art. To LeWitt drawing was the fundamental discipline. He thought for a long time about drawing directly on the wall, and then made his first wall drawing in October of 1968. He employed for his drawings the simplest and most basic means, the straightedge and the graphite pencil, using hatching and cross-hatching almost as primary exercises in how lines are multiplied or phrased within a drawing. Instructions for the first wall drawing which adapts to a pregiven space are dead simple:

Lines in four directions (horizontal, vertical, diagonal left & diagonal right) covering the entire surface of the wall. Note: The lines are drawn with hard graphite (8H or 9H) as close together as possible (1/16" apart, approximately) and are straight.

The tonal field that results is just that—a result, not an end (although as a result it immediately suggests comparisons with Color Field painting).

In 1968 LeWitt also made his first serial drawing on paper noting all the possible permutations and overlays of vertical lines, horizontal lines, diagonal lines from right to left, and diagonal lines from left to right. Starting with the four basic lines, he layered systematically until the final drawing was composed of all permutations. Color drawings employing three primary colors and black are drawn on the same system. It seems almost redundant to note that color and line are identical.

John Chandler, in discussing LeWitt, outlines the use and disuse of systems in intellectual history:

The current concern of artists with "systems" recalls the rejection of systems by the eighteenth-century philosophes. The seventeenth-century philosophers, following the model of Euclid's Elements, constructed elaborate systems, long chains of deductive reasoning where every link depended upon all those which preceded it and upon which all further links depended. The eighteenth century, following the lead of Newton and natural philosophy, rejected this kind of deduction and rejected a priori systems. Rather than beginning with principles and arriving at particulars, the process was reversed. Knowledge became more elastic, open-ended and concrete. Since then, attempts to make systems have been negligible, and when they have been formulated, they have been useless. The formulator of a system of aesthetics has nothing to say to working artists because he has not observed the relevant phenomena—in this case contemporary works of art. Nevertheless, some of the most beautiful of human productions have been these philosophical systems. What is more beautiful than the systems of Aquinas, Spinoza, Hobbes and Descartes? Every part in its appropriate place, deduced from those prior and antecedent to those that follow, the whole being an attempt to reduce the apparent variety to unity. Even their uselessness enhances their aesthetic quality, just as a ruined Gothic cathedral is perhaps more a work of art now than it was when it was functional. Although systems are useless for philosophy and science, their inherent adaptability to art must now be evident. It is perhaps in art that systems have found their proper domain. Not all art should be systematic, but all systems are art[42]

Systems have other attractions, too. A simple system may yield a complex field. Systems may seem logical but can be used to confound logic by extension to absurdity. Systems have no purpose outside of themselves: they engender purposeless, therefore aesthetic, mental processes.

In describing his art as conceptual, LeWitt maintains that the idea is more important than the result, although there must be a result. "It means that all of the planning and decisions are made beforehand and the execution is a perfunctory affair. The idea becomes a machine that makes the art."[43] Warhol had presented the artist as the machine that makes the art. But for the artist to be a convincing machine his touch has to be eliminated, and LeWitt interposes system between artist and work. The artist as craftsman is eliminated

SOL LeWITT. *LINES, COLORS, AND THEIR COMBINA-TIONS.* DECEMBER 1969-JANUARY 1970. SERIES OF SIXTEEN DRAWINGS IN BLACK, RED, BLUE, AND YELLOW INK, FRAMED AND MOUNTED IN METAL CONSTRUCTION; OVERALL, 49 X 49" (124.5 X 124.5 CM). COLLECTION MIA AND MARTIN VISSER, BERGEYK, THE NETHERLANDS

CHUCK CLOSE. *SELF-PORTRAIT.* 1975. INK AND GRAPHITE, 30 X 22 1/2" (76.2 X 57.1 CM). COLLECTION OF THE ARTIST

CHUCK CLOSE was born in 1940 in Monroe, Wash. He attended Everett Community College in Washington for two years; then in 1961 he studied art at the Yale Summer School of Music and Art, Norfolk, Conn. In 1961–62 Close studied at the University of Washington School of Art in Seattle. He transferred to the Yale University School of Art and Architecture and in two years received a B.F.A. and an M.F.A. Close worked as an instructor in art at the University of Massachusetts, Amherst, from 1965 to 1967. In 1966 Close did his first photographically realistic painting of a nude. He used the same style of painting for a series of black-and-white portraits done between 1967 and 1970. In 1971 Close began to use acrylic colors in another series of portraits.

Bibliography:

Adrian, Dennis. *Chuck Close.* Catalog. Chicago: Museum of Contemporary Art, 1972.

Dyckes, William. "The Photo as Subject: The Paintings and Drawings of Chuck Close," *Arts Magazine,* February 1974, pp. 28–33.

Nemser, Cindy. "An Interview with Chuck Close," *Artforum,* January 1970, pp. 51–55.

Scott, Gail R. *Chuck Close: Recent Work.* Catalog. Los Angeles County Museum of Art, 1971.

Spear, Athena. "Reflections on Close, Cooper, and Jenney," *Arts Magazine,* May 1970, pp. 44–47.

EVA HESSE. UNTITLED. 1966. WASH AND PENCIL, 11 7/8 X 9 1/8" (30 X 23.1 CM). THE MUSEUM OF MODERN ART, NEW YORK, GIFT OF MR. AND MRS. HERBERT FISCHBACH

EVA HESSE was born to a Jewish family in Hamburg, Germany, in 1936, during the height of Hitler's power. Separated from her parents for her first three years, she lived under the shelter of a Catholic family. She was reunited with her family in 1939 in New York City. Hesse began her art training at Pratt Institute, Brooklyn, in 1952, and in 1953 she studied at the Art Students League, New York. From 1954 to 1957 she attended Cooper Union, New York. Hesse attended Yale University, receiving a B.F.A. in 1959. Her first one-woman show was held at the Allan Stone Gallery, New York, in 1963. She lived and worked in Kettwig, Germany, in 1964–65. Hesse taught at New York's School of Visual Arts in 1968–69. On May 29, 1970, she died of a brain tumor.

Bibliography:

Lippard, Lucy R. "Eva Hesse: The Circle," *Art in America,* May–June 1971, pp. 68–73.

Nemser, Cindy. "An Interview with Eva Hesse," *Artforum,* May 1970, pp. 59–63.

Nemser, Cindy. *Art Talk: Conversations with 12 Women Artists.* New York: Charles Scribner's Sons, 1975, pp. 201–29.

Pincus-Witten, Robert. "Eva Hesse: Last Words," *Artforum,* November 1972, pp. 74–76.

Pincus-Witten, Robert. "Eva Hesse: Post-Minimalism into Sublime," *Artforum,* November 1971, pp. 32–44.

Pincus-Witten, Robert, and Shearer, Linda. *Eva Hesse: A Memorial Exhibition.* Catalog. New York: The Solomon R. Guggenheim Museum, 1972.

from the start; personal touch becomes an irrelevant issue. Lawrence Alloway first noted the connection between LeWitt and the concept of *disegno* as antecedent to and independent of execution, and he goes on to observe, "LeWitt's drawings propose a new relation between drawing as touch and drawing as intellectual content..."[44] LeWitt employs draftsmen and supplies instructions for independent draftsmen to execute the work. As long as he is the control, he does not care whether or not he is the direct agent in the sense that his hand is involved. He is not indifferent, however, to the visual quality of the work as it emerges, and in that sense his drawings, hand-executed by individuals, have to do with sensuous touch—but not his. Questions of touch have been a persistent issue since Abstract Expressionism. Pollock's handprints in *Number 1, 1948* adumbrate Johns's handprints in *Diver.* With each the issue becomes more literally a question about touch and the nature of illusion (Pollock's prints are perhaps accidental, Johns's are deliberate), about the artist's presence in the picture. A LeWitt drawing is not established as a LeWitt through recognition of the artist's touch—the single signatory line of Apelles—but, as Alloway writes, "LeWitt demonstrates the possibility of drawing as pure ratiocination...control is not a matter of manual participation but rather of setting up a system within which the execution of his system can only produce a LeWitt."[45] Therefore a LeWitt is also capable of being repeated, redrawn more than once. The system for a single wall drawing is adaptable to a variety of spaces and pregiven conditions—open-ended.

The comparison of LeWitt's wall drawings to *sinopie,* the underdrawings for late medieval and early Renaissance frescoes, is inevitable. The reticence of LeWitt's image and its intimate engagement with the irregularities of the wall surface are strongly suggestive of these earlier drawings. Specifically, however, LeWitt's work resembles the *netto*—the geometric underdrawing, the grid, on which the *sinopie* were organized. The *netto* was generated by a system, as is a LeWitt wall drawing. The *sinopie* of frescoes have an affecting existence as fragments, totally and forever unfinished. Romanticism raised the fragmentary and unfinished to the level of a cult; the ultimate fragment was a segment of a line—once again signatory and revealing. LeWitt's wall drawings are finished, but in relation to the art of the past they are fragments; they end where art was accustomed to begin. Fundamental to these works is their low level of perceptibility. Essences, they are like veils that threaten to dissolve before our eyes; to notice them at all demands attention. Large in scale, they become segments of the actual environment; but while the art takes up more of the space of the world, our reaction to it occurs much less in relation to the world and much more in a space somewhere in the "mind's eye." They impose on the public space a need to focus in, to close out the objects of the world that impinge on consciousness, in order to create a private space for contemplation.

LIKE LeWitt's, the work immediately succeeding Minimalism has, up to the present, based its strategy for making art on "one form or another of rationalist content....[Its] physical manifestations merely mirrored the informational content."[46] The early part of the roughly ten-year period covered by this description was dominated by Conceptual art—art in which idea was frequently more important than physical manifestation. More recently, however, the physical manifestation, while continuing to reflect information, has taken on increasing importance for its visual quality.

Conceptual art was a movement embracing work as varied as earth art, street works, and Robert Morris's "anti-form," but most often it was identified with word art. Written words, alphabets stand in relation to verbal utterance as drawing in relation to sight. Words and drawings have a common origin as symbolizations of experience, symbols for things. The association of writing and drawing—hieroglyphics, the extension of writing into calligraphy, the elaboration of drawing by written inscription, and the elaboration of written

BRUCE NAUMAN. *DRAWING FOR "MY LAST NAME EXTENDED VERTICALLY 14 TIMES."* 1967. GRAPHITE AND PASTEL, 6' 9 3/4" X 34" (207.6 X 86.3 CM). NICHOLAS WILDER GALLERY, LOS ANGELES

BRUCE NAUMAN was born in 1941 in Fort Wayne, Ind. From 1960 to 1964 he attended the University of Wisconsin, Madison, first as a mathematics major, then studying art under Italo Scanga. He received an M.F.A. from the University of California, Davis, in 1966. His first one-man show, of fiberglass sculpture, was held at the Nicholas Wilder Gallery, Los Angeles, in 1966. During that year Nauman made several films and taught in the summer at the San Francisco Art Institute. In 1968 he had his first New York one-man exhibition at Leo Castelli Gallery. In the same year he received a grant from the National Endowment for the Arts to make videotapes. In 1968 Nauman traveled to Paris for his first exhibition at Ileana Sonnabend Gallery. He taught sculpture at the University of California, Irvine, in the spring of 1970 and received a summer grant from the Aspen Institute for Humanistic Studies. He had a major one-man exhibition in 1972-73 at the Los Angeles County Museum of Art and the Whitney Museum of American Art, New York. Nauman continues to make sculptures and environments and works extensively in films.

Bibliography:

Butterfield, J. "Bruce Nauman: The Center of Yourself," *Arts Magazine,* February 1975, pp. 53-55.
Danieli, Fidel A. "The Art of Bruce Nauman," *Artforum,* December 1967, pp. 15-19.
Harten, Jurgen. "T for Technics, B for Body," *Art and Artists,* November 1973, pp. 28-33.
Livingston, Jane, and Tucker, Marcia. *Bruce Nauman.* Catalog. Los Angeles County Museum of Art, 1972.
Pincus-Witten, Robert. "Bruce Nauman: Another Kind of Reasoning," *Artforum,* February 1972, pp. 30-37.
Sharp, Willoughby. "Bruce Nauman," *Avalanche,* Winter 1971, pp. 23-25.
Sharp, Willoughby. "Nauman Interview," *Arts Magazine,* March 1970, pp. 22-27.
Tucker, Marcia. "PheNAUMANology," *Artforum,* December 1970, pp. 38-44.

JOHN CAGE. *PAGE FROM CONCERT FOR PIANO AND ORCHESTRA*. 1958. INK, 11 X 17" (27.9 X 43.2 CM). COLLECTION JASPER JOHNS, NEW YORK

JOHN CAGE was born in 1912 in Los Angeles. He attended Pomona College in Claremont, Calif., from 1928 to 1932. Cage studied music with Richard Fuhlig, Adolph Weiss, Henry Cowell, and Arnold Schoenberg. He is an important contemporary composer whose music is involved more with the concept of time than with harmonics. Starting in 1943 Cage performed his music with the dancer Merce Cunningham, and in 1948 they were well received at Black Mountain College, N.C. In 1949 he received a Guggenheim Fellowship and won an award from the National Academy of Arts and Letters. In 1952 Cage, Merce Cunningham, Charles Olson, and Robert Rauschenberg presented at Black Mountain College a mixed-media theatrical event considered by some to be the first "happening." Cage was elected to the National Institute of Arts and Letters in 1968. He was also a Fellow of the Center for Advanced Studies at Wesleyan University in Middletown, Conn.

Bibliography:

Duberman, Martin. *Black Mountain: An Exploration in Community.* New York: E.P. Dutton, 1972.
"John Cage in Los Angeles," *Artforum,* February 1965, pp. 17-19.
Kostelanetz, Richard. *John Cage.* New York: Praeger, 1970.
Paik, Nam June. *John Cage Film.*
Rose, Barbara. *John Cage.* Catalog. Milan: Galleria Schwarz, 1971.
Tomkins, Calvin. *The Bride and the Bachelors: The Heretical Courtship in Modern Art.* New York: Viking Press, 1965, pp. 69-144.

HANNE DARBOVEN. *16 DRAWINGS*. 1968. PEN AND INK AND PENCIL, 23 5/8 X 17 1/8" (60 X 43.5 CM). COLLECTION MIA AND MARTIN VISSER, BERGEYK, THE NETHERLANDS

HANNE DARBOVEN was born in Munich in 1941 and now resides in Hamburg. From 1966 to 1968 she lived in New York. Darboven was included in *Eight Contemporary Artists* at the Museum of Art in 1974 and has had a major one-woman exhibition at the Stedelijk Museum in Amsterdam.

Bibliography:

Licht, Jennifer. *Eight Contemporary Artists.* Catalog. New York: The Museum of Modern Art, 1974.
Lippard, Lucy R. "Hanne Darboven: Deep in Numbers," *Artforum,* October 1973, pp. 35-39.
Thwaites, John Anthony. "The Numbers Game," *Art and Artists,* January 1972, pp. 24-25.
Weiss, Evelyn. *Hanne Darboven.* Catalog. XII Bienal de São Paulo, 1973.

CARL ANDRE. *STRUCTURE WHITE CONSCIOUSNESS.* 1965. COLLAGE, 5 1/4 X 21 7/8" (13.3 X 55.5 CM). COLLECTION MR. AND MRS. MICHAEL CHAPMAN, NEW YORK

CARL ANDRE was born in 1935 in Quincy, Mass. He studied with Patrick Morgan at the Phillips Academy, Andover, Mass., from 1951 to 1953 and attended Kenyon College in Ohio for a brief time. In 1954 he traveled to England and France. Andre served in the U.S. Army as an intelligence analyst in South Carolina from 1955 to 1957. A year after his discharge, he began to work with Frank Stella, making his first wood sculptures in Stella's studio. From 1960 to 1964 Andre worked as a railroad brakeman while continuing to practice his art. His first one-man exhibition was held at the Tibor de Nagy Gallery, New York, in 1965. In 1968 he won a National Endowment for the Arts award. Andre gave a reading of his poetry at an exhibition in Oxford, England, in 1975. He currently lives and works in New York City.

Bibliography:

Bourdon, David. "The Razed Sites of Carl Andre," *Artforum,* October 1966, pp. 15-17.
Carl Andre. Catalog. The Hague: Gemeentemuseum, 1969.
Carl Andre: Sculpture 1958-1974. Catalog. Bern: Kunsthalle, 1975.
Sharp, Willoughby. "Carl Andre: Interview," *Avalanche,* Fall 1970, pp. 18-27.
Siegel, Jeanne. "Carl Andre: Artworker," *Studio International,* November 1970, pp. 175-79.
Waldman, Diane. *Carl Andre.* Catalog. New York: The Solomon R. Guggenheim Museum, 1970.

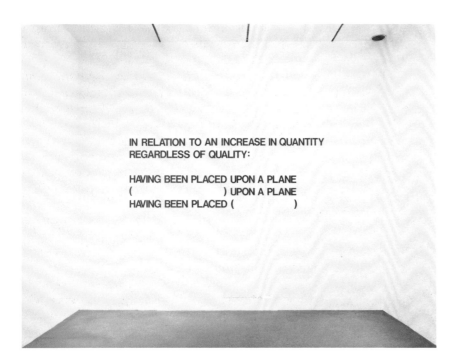

IN RELATION TO AN INCREASE IN QUANTITY
REGARDLESS OF QUALITY:

HAVING BEEN PLACED UPON A PLANE
() UPON A PLANE
HAVING BEEN PLACED ()

LAWRENCE WEINER. *IN RELATION TO AN INCREASE IN QUANTITY REGARDLESS OF QUALITY....* 1973-74. BLACK LETTERS ON WHITE WALL, SIZE VARIABLE; INSTALLATION 36 1/8" X 9' 1 3/4" (91.7 X 278.7 CM). THE MUSEUM OF MODERN ART, NEW YORK, GIVEN ANONYMOUSLY

LAWRENCE WEINER was born in 1940 in the Bronx, N.Y. Although initially a painter in New York, he moved to California in the early 1960s and worked exclusively in earthworks. Weiner returned to New York in the mid-1960s and resumed his painting. He gave it up again in the spring of 1968 and decided to have his work exist primarily as proposals in his note-books. In 1973 Weiner made his first film, *A First Quarter.*

Bibliography:

"Artist and Politics: A Symposium," *Artforum*, September 1970, p. 39.
Cameron, Eric. "Lawrence Weiner: The Books," *Studio International*, January 1974, pp. 2–8.
Heinemann, Susan. "Lawrence Weiner: Given the Context," *Artforum*, March 1975, pp. 36–37.
Kent, Sarah. "Lawrence Weiner at the Jack Wendler Gallery, London," *Studio International*, November 1973, pp. 197–98.
Kosuth, Joseph. "Art after Philosophy," *Studio International*, November 1969, pp. 160–61.
Lovell, Anthony. "Lawrence Weiner," *Studio International*, March 1971, pp. 126–27.
Rose, Arthur. "Four Interviews," *Arts Magazine*, February 1969, p. 23.
When Attitudes Become Form. London: Institute of Contemporary Art, 1969.
Wooster, Ann-Sargent. "Lawrence Weiner at Castelli Downtown," *Art in America*, March-April 1975, p. 93.

ART & LANGUAGE. CHART (WITH DETAIL). 1972. PENCIL AND BALL-POINT PEN ON GRAPH PAPER, PHOTOCOPIES, TAPED; OVERALL, 8' 9 1/4" X 9' 2 7/8" (267.3 X 281.6 CM). COLLECTION MARGOT KRÄTZ, BUCHSLAG-UBER NEU-ISENBERG, WEST GERMANY

ART & LANGUAGE group was founded in Coventry, England, in May 1968 by Terry Atkinson, David Bainbridge, Michael Baldwin, and Harold Hurrell, but the research of the group had begun as early as 1966. The first issue of *Art-Language* was published in May 1969. Joseph Kosuth became the American editor. Later, Ian Burn and Mel Ramsden became associated with the group. The members were all interested in linguistic analysis and the history of language, and in the relationship between art and philosophy.

Bibliography:

Art-Language. Vol. I: No. 1, May 1969; No. 2, February 1970; No. 3, June 1970; No. 4, November 1971. Vol. II: No. 1, February 1972; No. 2, Summer 1972; No. 3, September 1973; No. 4, June 1974. Vol. III: No. 1, September 1974; No. 2, May 1975.
De Europa. Catalog. New York: John Weber Gallery, 1972.
Maenz, Paul, and Vries, Gerd de, eds., *Art & Language.* Cologne: M. DuMont Schauberg, 1972.
Vries, Gerd de, ed. *On Art.* Cologne: M. DuMont Schauberg, 1974.

text by illustration—is evident in the oldest traditional expressions in literate civilizations. The alphabet and notation by number systems are the first conceptualizations, the first symbolizations of experience, taught in our schools, and their expression is graphic.

The ambition of Conceptual artists like Joseph Kosuth and Lawrence Weiner, for whom art is not in the object but in the idea, puts language in a special relation to visual art. Text is all, the visual part is unnecessary. "Obsessed with the idea he must express, the artist takes appearances only as accessory."[47] For Kosuth and Weiner, the concept is the starting point for an art in which the classical identification between spectator and art object takes place much more in the head than in the eye.

The ambition to return to the roots of experience, to re-create the primary experience of symbolization uncontaminated by the attitudes attached to visual modes (whether representational or abstract), is at the heart of Conceptual art. Many Conceptual artists—especially those who, like Hanne Darboven, are involved with notational systems—profess to be uninterested in aesthetics. This claim, however, does not remove their work from a kind of primitive or atavistic aesthetic, lodged in the physical, almost unconscious satisfaction of repetitiously marking off a series of units. A chart of notations issued by Art and Language, the group of British and American Conceptual artists, reveals this preconscious, unwilled aesthetic. Hanne Darboven's involvement with this kind of aesthetic is overt. Her desire for orderly, soothing patterning is obsessive; she has written in her own work a phrase from Jorge Luis Borges: "Time is the substance I am made of." Darboven's drawing of charts that mark off time is a way of passing time, contracting it visually so that hours pass as moments, days as minutes. Like much Conceptual art, it is systematic; the rules are arbitrary and set up in advance.

The rule-dominated anti-aesthetic which generates its own style is a tradition of modern art. It made its first appearance in literature, in the work of the French Symbolist poets, especially Mallarmé. Somewhat later, Raymond Roussel went so far as to provide himself with a set of rules for living—which he extended into a system for writing intended to eliminate the possibility of stylistic effects. Of course this kind of rule-making produced its own effects, but the result was a style with a remarkable clarity of its own. (In the same way rules lead to style for LeWitt.) Roussel's mania for order was "a need to arrange everything according to rules devoid of any ethical character, rules in their pure state, just as the rules to which he conformed in his writing seem exempt from any aesthetic intention."[48] His dislocations of phrases and use of phrases with double meanings have a direct connection with Duchamp's word and image puns—for instance, Duchamp's title *Fresh Widow*, for "French Window." This tradition of the rule-dominated image, literary or visual, is at the base of word art—perhaps more than Apollinaire's visual poems, which are the standard exemplars of the marriage of word and image.

Mel Bochner's first mature work was generated by system and rule. Particularly interested in word-and-image functions, he made a number of notational works based on numerical systems. This approach then widened into an interest in perceptual problems and visually more sensuous work.

The art-making strategies used by Dorothea Rockburne are based partly on topological geometry, partly on behavioral and perceptual psychology, and partly on classical models (for instance, the Golden Section). In the mid-sixties, as we have observed, there was a general interest in a return to fundamentals; geometry was considered one fundamental, drawing another. Rockburne was actually trained at an academy, with drawing as her first discipline.

In her diaries Rockburne has transcribed passages from William Ivins's *Art and Geometry,*[49] among them the following: "...visually things are not located in an independently existing space; space, rather, is a quality or relationship of things that has no existence without them." This sense of spatial definition sets the terms for Rockburne's exploration of form. Drawing is fundamental to that exploration; the nature of line, how it is generated, and how linear

MENTAL EXCERCISE;
ESTIMATING A CENTERED VERTICAL
RED LINE: DRAWN FIRST, FREEHAND
GREY LINE: DRAWN LAST, BY STRAIGHTEDGE
MEL BOCHNER, NYC, 1972.

MEL BOCHNER. MENTAL EXERCISE SERIES. 1972. COLORED PENCIL, GRAPHITE, PEN AND INK, AND ERASER, 22 3/8 X 30" (56.8 X 76.2 CM). THE MUSEUM OF MODERN ART, NEW YORK, MRS. JOHN D. ROCKEFELLER 3RD FUND AND NATIONAL ENDOWMENT FOR THE ARTS MATCHING PURCHASE FUND

MENTAL EXERCISE: ESTIMATING A CENTERED VERTICAL

MENTAL EXERCISE: ESTIMATING A CORNER TO CORNER DIAGONAL

MENTAL EXERCISE: ESTIMATING A CIRCLE

MENTAL EXERCISE: ESTIMATING THE CENTER

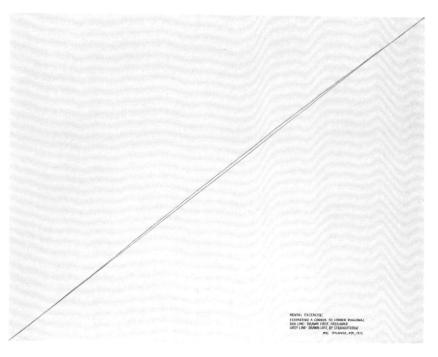

MENTAL EXCERCISE;
ESTIMATING A CORNER TO CORNER DIAGONAL
RED LINE: DRAWN FIRST, FREEHAND
GREY LINE: DRAWN LAST, BY STRAIGHTEDGE
MEL BOCHNER, NYC, 1972.

MEL BOCHNER was born in 1940 in Pittsburgh, Pa. He received a B.F.A. from Carnegie Institute of Technology, Pittsburgh, where he was a student from 1958 to 1962. He graduated with a major in art and a minor in philosophy. In 1963 he was a philosophy major at Northwestern University, Evanston, Ill. In 1964 Bochner moved to New York, where he became friendly with Eva Hesse, Robert Smithson, Brice Marden, Sol LeWitt and Dorothea Rockburne. From 1965 to 1973 he taught at the School of Visual Arts, New York. Bochner has written numerous articles on contemporary art.

Bibliography:

Bochner, Mel. "Mel Bochner by Mel Bochner," *Data,* February 1972, pp. 62-67.

Bochner, Mel. *Notes on Theory.* Catalog. Kingston, R.I.: University of Rhode Island, 1971.

Bochner, Mel. "Primary Structures," *Arts Magazine,* June 1966, pp. 32-34.

Bochner, Mel. "The Serial Attitude," *Artforum,* December 1967, pp. 27-34.

Pincus-Witten, Robert. "Mel Bochner: The Constant as Variable," *Artforum,* December 1972, pp. 28-34.

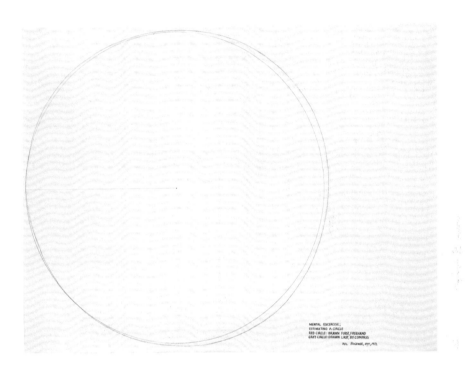

MENTAL EXERCISE;
ESTIMATING A CIRCLE
RED CIRCLE: DRAWN FIRST, FREEHAND
GREY CIRCLE: DRAWN LAST, BY COMPASS

MEL BOCHNER, NYC, 1972.

MENTAL EXERCISE;
ESTIMATING THE CENTER
RED DOT: DRAWN FIRST, FREEHAND
GREY DOT: DRAWN LAST, MEASURED

MEL BOCHNER, NYC, 1972.

DOROTHEA ROCKBURNE. *NEIGHBORHOOD.* **1973. VELLUM, COLORED AND GRAPHITE PENCIL ON WHITE WALL, SIZE VARIABLE; INSTALLATION 16' (488 CM) LONG. COLLECTION MR. AND MRS. J. FREDERIC BYERS III, NEW YORK**

DOROTHEA ROCKBURNE was born in 1934 in Verdun, Quebec, Canada. In 1956 she received a B.F.A. from Black Mountain College, N.C. She became an instructor of art history at the School of Visual Arts, New York, in 1970. In the same year she had her first one-woman show at Bykert Gallery, New York. In 1972 Rockburne was awarded a Guggenheim Fellowship. She became a U.S. citizen in 1974. She was included in the *Eight Contemporary Artists* exhibition in 1974 at The Museum of Modern Art and has had numerous exhibitions both in Europe and the U.S.

Bibliography:

Bochner, Mel. "A Note," *Artforum*, March 1972, p. 28.
Boice, Bruce. *Dorothea Rockburne.* Catalog. Hartford Art School, 1973.
Licht, Jennifer. *Eight Contemporary Artists.* Catalog. New York: The Museum of Modern Art, 1974.
Licht, Jennifer. "An Interview with Dorothea Rockburne," *Artforum*, March 1972, pp. 34-36.
Pincus-Witten, Robert. "Works and Statements," *Artforum*, March 1972, pp. 29-33.

RICHARD SERRA. *ABSTRACT SLAVERY*. 1974. OIL-STIK ON BELGIAN LINEN, 9' 6" X 17' 8" (291.4 X 542.2 CM). LEO CASTELLI GALLERY, NEW YORK

RICHARD SERRA was born in 1939 in San Francisco. He received a B.A. from the University of California, Santa Barbara. He also received a B.A. and M.F.A. from Yale University. Serra's first one-man exhibition was held in 1966 at La Salita, Rome. He has been included in numerous group exhibitions both in Europe and the U.S. Serra has constructed a number of monumental outdoor sculptures, including a work for the Rijksmuseum Kröller-Müller, Otterlo, the Netherlands.

Bibliography:

Krauss, Rosalind. "Sculpture Redrawn," *Artforum*, May 1972, pp. 38-43.
Kuspit, D. B. "Richard Serra's City Piece," *Arts Magazine*, January 1975, pp. 48-51.
McShine, Kynaston, ed. *Information*. Catalog. New York: The Museum of Modern Art, 1970.
Monte, James, and Tucker, Marcia. *Anti-Illusion: Procedures/Materials*. New York: Whitney Museum of American Art, 1969.
Options and Alternatives: Some Directions in Recent Art. Catalog. New Haven: Yale University Art Gallery, 1973.
Pincus-Witten, Robert. "Richard Serra: Slow Information," *Artforum*, September 1969, pp. 34-39.
Serra, Richard. "Play It Again, Sam," *Arts Magazine*, February 1970, pp. 24-27.
Thwaites, John Anthony. "Working Out," *Art and Artists*, March 1974, pp. 34-37.

PALERMO. *TRIPTYCH VI.* 1974. PENCIL, THREE PANELS, EACH 6 X 6' (182.8 X 182.8 CM). HEINER FRIEDRICH GALLERY, NEW YORK

PALERMO (Peter Heister-Kamp) was born in 1943 in Leipzig, Germany. He took his pseudonym from the Mafia gangster Blinky Palermo. From 1962 to 1967 Palermo studied at the Düsseldorf Academy under Bruno Goller and Joseph Beuys. He was represented in the Paris Biennale, in 1971, and the XIII Bienal, São Paulo, in 1975. Palermo moved to New York in 1974.

Bibliography:

Jappe, Georg. "Young Artists in Germany," *Studio International,* February 1972, p. 68.
Palermo. (Statement), *Kunstwerk,* June-July 1968, p. 49.
Rinn, Ludwig. *Palermo Zeichnungen 1963-73.* Catalog. Munich: Kunstraum, 1974.

operations modify space have been concerns of her work for several years. Her means are simple and straightforward: paper and pencil, carbon paper. The individual line is so reticent and nonrevealing in terms of touch that it attains the extremity of privacy.

Rockburne is concerned with making the material yield forms inherent in its own structure. In her notes she describes a typical operation for arriving at a visual structure:

The carbon paper is folded on the square of itself and on its diagonal axis. Utilizing these folds and sometimes edges, the paper is folded, flipped and re-opened in various ways. When in position the fold lines are marked, allowing a transfer and a certain interaction between the wall and the carbon paper. This interaction is based on the physical properties of the carbon paper which I found helpful to an understanding of transitive structure. The paper is allowed to leave the trace of its own decision-forming system of coordinates which holds a reference of actions already indicated. The structure and the operations are the same thing[50]

Rockburne's last line evokes echoes of Pollock—the structure and gesture are one—but some distance has been traveled to reach the same equation. The operation remains intuitive at its root but subject to stringent rules imposed by the artist. The rules are simple; the resulting strategies are complex and leave complex and not wholly transparent traces. Rockburne undermines classicism from a position within it. Her space is ultimately not one of order, but of the potential dissolution of order. Her structure, developing logically, according to an apparently rule-regulated system, opens out and extends itself until it teeters on the brink of chaos.

The inevitable variations in the appearance of Sol LeWitt's wall drawings, due to the different touch of individual draftsmen employed, are a reminder that even the most conceptual work involves a reconciliation with the autographic function of drawing. Richard Serra has chosen to concentrate on the mark as a trace of process, compacting it into an intense, tightly "built" surface. Seurat's black was broad, gently inflected, calm, however deep and dense; Serra's is the opposite, filled with continuous visual incident. The process by which the work was made is visible in the surface, a dense accretion of numerous strokes of black acrylic paint-stick, overdrawn with charcoal. The softer surface qualities of the charcoal are played off against the harder surface of the acrylic, and the two are built up in strokes and layers to form a muscular ("kinesthetic") skin that is light-absorbing here, reflective there. In certain lights the surface is distinctly Impressionistic. What had been an earlier concern with process on Serra's part has now shifted and is contained and compacted into the object. Serra's large black drawings of the mid-seventies are intended as two-dimensional analogues to the steel and lead plates of his large outdoor sculptures. As in his sculpture there is an assertion of absolute physical presence—complete. Serra insists on the drawing as a physical extension of one's own body and gesture. Scale becomes a function of size; internal scale is not an issue—there are no relational parts. Whatever space one finds in the drawing is the function of extension, and of the constantly fluctuating ambiguous reading of flat or deep: first glance indicates flatness, concentration reveals infinite depth, a momentary distraction will bring back the flat surface. Drawing, for Serra (and ultimately for LeWitt, although more personally assimilated and adjusted to other modes of feeling and expression), is related to the "Constructivist mode"—not to any specific artist or work, but to the tradition. The idea of constructing and the linear form do relate to Naum Gabo and Antoine Pevsner's *Realistic Manifesto,* written in Moscow in 1920: "We renounce in line its descriptive value: in real life there are no descriptive lines; description is an accidental trace of a man on things; it is not bound up with the essential life and constant structure of the body.... We affirm the line only as a direction of the static forces and rhythm in objects. We renounce color.... We affirm that the tone of a substance, i.e., its light-absorbing material body, is its only pictorial reality."[51]

MICHAEL HEIZER. *CIRCULAR SURFACE PLANAR DIS-*
PLACEMENT **(DETAIL). JEAN DRY LAKE, NEVADA,**
1971. EARTHWORK, 400 X 800' (121.88 X 243.75 M).
LINES INSCRIBED ON SURFACE OF DESERT WITH
MOTORCYCLE

MICHAEL HEIZER was born in 1944 in Berkeley,
Calif. His father was a geologist-archaeologist.
In 1963-64 he studied at the San Francisco Art
Institute. Heizer began as a painter, but in 1967
he created his first earthworks. He had his first
one-man shows in 1969 at the Heiner Friedrich
Gallery, Munich, and the Konrad Fischer
Gallery, Düsseldorf. In 1970 Heizer had his
first one-man New York show at the Dwan
Gallery. He resumed painting in 1972 but
continues to create earthworks.

Bibliography:

Bell, Jane. "Positive and Negative: New Paintings by
 Michael Heizer," *Arts Magazine,* November 1974, pp.
 55-57.
"Discussions with Heizer, Oppenheim, Smithson,"
 Avalanche, Fall 1970, pp. 48-71.
Heizer, Michael. "The Art of Michael Heizer," *Artforum,*
 December 1969, pp. 32-39.
Herrera, Hayden. "Michael Heizer Paints a Picture," *Art
 in America,* November 1974, pp. 92-94.
Müller, Grégoire. "Michael Heizer," *Arts Magazine,*
 December 1969, pp. 42-45.
Waldman, Diane. "Holes without History," *Art News,*
 May 1971, pp. 44-48, 66-68.

ROBERT SMITHSON. *SLATE GRIND #6.* **1973. IN-**
CISED SLATE, 2 1/2 X 16 X 13" (6.4 X 40.1 X 33 CM).
COLLECTION NANCY HOLT, NEW YORK

ROBERT SMITHSON was born in 1938 in
Passaic, N.J. He studied at the Art Students
League, New York (1955-56), and the Brooklyn
Museum School (1956). His first one-man ex-
hibition of sculpture was held in 1959 at the
Artists Gallery, New York. In 1966 Smithson
began to design earthworks. In the same year
he was one of the artist-consultants hired by
an architectural-engineering firm to create
projects for the Dallas-Fort Worth Regional
Airport. He was a lecturer on art at Columbia
University, Yale University, and New York Uni-
versity. In 1972 Smithson won an award from
The Art Institute of Chicago. He collaborated
on a film in 1973 with his artist-filmmaker wife,
Nancy Holt. On July 20, 1973, Smithson died
in a plane crash while inspecting one of his
earthworks, *Amarillo Ramp,* in Texas.

Bibliography:

Alloway, Lawrence. "Robert Smithson's Development,"
 Artforum, November 1972, pp. 52-61.
Coplans, John. "Robert Smithson: The Amarillo Ramp,"
 Artforum, April 1974, pp. 36-45.
"Discussions with Heizer, Oppenheim, Smithson," *Ava-
 lanche,* Fall 1970, pp. 48-71.
Ginsburg, Susan. *3D Into 2D: Drawing for Sculpture.*
 Catalog. New York Cultural Center, 1973.
Ginsburg, Susan, and Masheck, Joseph. *Robert Smithson:
 Drawings.* Catalog. New York Cultural Center, 1974.
McShine, Kynaston. *Primary Structures.* Catalog. New
 York: The Jewish Museum, 1966.
Müller, Grégoire. *The New Avant-Garde.* New York:
 Praeger, 1972.
Robbin, Anthony. "Smithson's Non-Sites Sights," *Art News,*
 February 1969, pp. 50-53.
Smithson, Robert, and Müller, Grégoire. "...The Earth,
 Subject to Cataclysms, Is a Cruel Master," *Arts Magazine,*
 November 1971, pp. 36-41.

ROBERT MANGOLD. CIRCLE DRAWINGS #1 and #2 FROM PORTFOLIO OF EIGHT DRAWINGS. 1973. PENCIL, EACH 39 X 27 1/2" (99 X 69.8 CM). COLLECTION MR. AND MRS. J. FREDERIC BYERS III, NEW YORK

ROBERT MANGOLD was born in 1937 in North Tonawanda, N.Y. He attended the Cleveland Institute of Art from 1956 to 1959. In 1959 he received a fellowship from the Yale University Summer School of Music and Art. He received a B.F.A. from Yale University School of Art and Architecture in 1961 and an M.F.A. in 1963. Mangold began teaching at the School of Visual Arts, New York, in 1963. His first one-man show was held in 1964 at Thibaut Gallery, New York. Mangold has taught at several schools: Hunter College, New York (1964-65), Skowhegan Summer Art School, Maine (1968), Yale Summer School of Music and Art (1969), and Cornell University Summer Art School (1970). He had a one-man show at The Solomon R. Guggenheim Museum, New York, in 1971.

Bibliography:

Krauss, Rosalind. "Robert Mangold: An Interview," *Artforum*, March 1974, pp. 36-38.
Lippard, Lucy R. *Changing: Essays in Art Criticism.* New York: E.P. Dutton, 1971, pp. 130-40.
Lippard, Lucy R. "Robert Mangold and the Implications of Monochrome," *Art and Literature*, Summer 1966, pp. 116-30.
Options and Alternatives: Some Directions in Recent Art. Catalog. New Haven: Yale University Art Gallery, 1973.
Spector, Naomi. *Robert Mangold.* Catalog. La Jolla Museum of Contemporary Art, 1974.
Waldman, Diane. *Robert Mangold.* Catalog. New York: The Solomon R. Guggenheim Museum, 1971.

RICHARD TUTTLE. *WIRE PIECE.* 1972. PENCIL AND WIRE ON WALL, 12" (30.5 CM) HIGH (SIGHT). BETTY PARSONS GALLERY, NEW YORK

RICHARD TUTTLE was born in 1941 in Rahway, N.J. He received a B.A. from Trinity College, Hartford, Conn., in 1963 and studied art at Cooper Union, New York, from 1963 to 1965. Tuttle had his first one-man show at the Betty Parsons Gallery, New York, in 1965. He received a grant from the American Center for Students and Artists to study in Paris in 1965-66. In 1968 he received a grant from the National Council of the Arts and spent half the year traveling in Japan. Tuttle's work was shown in a Projects exhibition in 1972 at The Museum of Modern Art and was included in the prints exhibition *Cut, Folded, Pasted, Torn* at the Museum in 1974. He also had important one-man shows at The Clocktower, New York, in 1973 and at the Whitney Museum of American Art in 1975.

Bibliography:

Josephson, Mary. "Richard Tuttle at Betty Parsons," *Art in America*, May 1972, pp. 31-33.
Lubell, Ellen. "Wire/Pencil/Shadow," *Arts Magazine*, November 1972, pp. 50-52.
Options and Alternatives: Some Directions in Recent Art. Catalog. New Haven: Yale University Art Gallery, 1973.
Pincus-Witten, Robert. "The Art of Richard Tuttle," *Artforum*, February 1970, pp. 62-67.

FOLLOWING PAGE: ROBERT MORRIS. LIGHT-CODEX-ARTIFACTS I (AQUARIUS). 1974. VASELINE AND GRAPHITE ON WALL, 12' 2 1/4" X 22' 9 1/2" (371.7 X 695.1 CM). THE ART MUSEUM, PRINCETON UNIVERSITY, PRINCETON, N.J.

ROBERT MORRIS was born in 1931 in Kansas City, Mo. He studied at the University of Kansas and Kansas City Art Institute (1948-50), California School of Fine Arts (1950-51), and Reed College in Oregon (1953-55). Morris was involved in painting and theater improvisation in San Francisco from 1955 through 1959. He had his first one-man show at Dilexi Gallery, San Francisco, in 1957. In 1959 and 1960 he explored filmmaking and in 1961 made his first sculpture. In 1962 and 1963 he was enrolled in a graduate program at Hunter College, New York, and since 1964 he has taught there. From 1963 to 1965 Morris was involved as a dancer and choreographer. Since 1965 he has produced large-scale sculptures, developed proposals for earthworks, and made further explorations in film and performed works. Morris has been an important proselytizer of Minimal art and an active critic in art magazines. He lives and works in New York.

Bibliography:

Antin, David. "Art and Information 1: Grey Paint-Robert Morris," *Art News,* April 1966, pp. 22-24, 56-58.
Burnham, Jack. "Robert Morris: Retrospective in Detroit," *Artforum,* March 1970, pp. 67-75.
Friedman, Martin. "Robert Morris: Polemics and Cubes," *Art International,* December 1966, pp. 23-27.
Gilbert-Rolfe, Jeremy. "Robert Morris: The Complication of Exhaustion," *Artforum,* September 1974, pp. 44-49.
Michelson, Annette. *Robert Morris.* Catalog. Washington, D.C.: Corcoran Gallery of Art, 1969.
Morris, Robert. "Aligned with Nazca," *Artforum,* October 1975, pp. 26-39.
Morris, Robert. "Anti-Form," *Artforum,* April 1968, pp. 33-35.
Sylvester, David. *Robert Morris.* Catalog. London: The Tate Gallery, 1971.
Tucker, Marcia. *Robert Morris.* Catalog. New York: Whitney Museum of American Art, 1970.

THE recent drawings of Robert Morris insist once again on the intimate tie between drawing and touch, between art and the body. Morris, a peer of LeWitt and Judd in Minimal art, has moved between drawing as notation and as conceptual projection for sculpture—between performance works and the "dumb object" in sculpture. Throughout his career he has displayed a distrust of formalism for its own sake. If we have been discussing a movement in the arts toward more "Platonic" ideational modes as opposed to sensuous modes, Morris represents the opposition from within. In his most recent work he calls for an art of a more private nature, more intimate in relation to the body, noninformational and contemplative in its establishment of a private space:

The art of the sixties was, by and large, open and had an impulse for public scale, was informed by a logic in its structure, sustained by a faith in the significance of abstract art and a belief in an historical unfolding of formal modes which was very close to a belief in progress. The art of that decade was one of dialogue: the power of the individual artist to contribute to public, relatively stable formats...Midway into the seventies one energetic part of the art horizon has a completely different profile. Here the private replaces the public impulse. Space itself has come to have another meaning. Before it was centrifugal and tough, capable of absorbing monumental impulses. Today it is centripetal and intimate, demanding demarcation and enclosure. Deeply skeptical of experiences beyond the reach of the body, the more formal aspect of the work in question provides a place in which the perceiving self might take measure of certain aspects of its own physical existence. Equally skeptical of participating in any public art enterprise, its other side exposes a single individual's limit in examining, testing, and ultimately shaping the interior space of the self[52]

The need for such a space is manifest; it comes from more than one source and expresses itself on many levels. It not only asserts itself in terms of our physical existence, but reaches toward the rationalizing function of the mind as well. We began with Rauschenberg's admission into art of the impinging noise and static of the world, and have come full circle to a need for exclusion, concentration, and contemplation. As read today, LeWitt's and Rockburne's spaces move in the direction of the contemplative and the private. Drawing itself, as a private and intimate art, enforces this reading. On the public scale, such drawings—reduced to their "bones" and addressed to our immediate perception rather than our conventionalized responses—call out to that part of the mind which is contemplative and aware of immaterial reality, that part which is capable of intellectual contemplation. Such work makes us aware of the functioning of consciousness itself; low in sensuous content and visual excitement, it asks for an exclusion of the noise of the world. For Morris, sensuous physical perception in art is allied to an activist view of knowledge. In a more analytically distanced art such as LeWitt's, there dominates a contemplative mind whose knowledge comes, as Heraclitus said, "of listening to the essence of things."

Saul Bellow, writing in *Critical Inquiry,* calls attention to the "crisis and noise" in which we live. He is no advocate of escapism; his point is that busy agitation does not best enable us to deal with contemporary problems. He calls for "the recovery of significant space by the individual, the reestablishment of a region about every person through which events must make their approach, a space in which they can be received on decent terms, intelligently, comprehensively, and contemplatively....for art and literature there is no choice. If there is no significant space, there is no judgment, no freedom, we determine nothing for ourselves individually."[53]

Bellow's metaphorical space is coterminous with the literal space that is increasingly the concern of our artists. At this moment it seems as if drawing may be capable of delivering that space to us. Drawing now presides over a restoration of the contemplative function to art. Constantly creating new orders, new forms, art filters the old while preserving and enriching it.

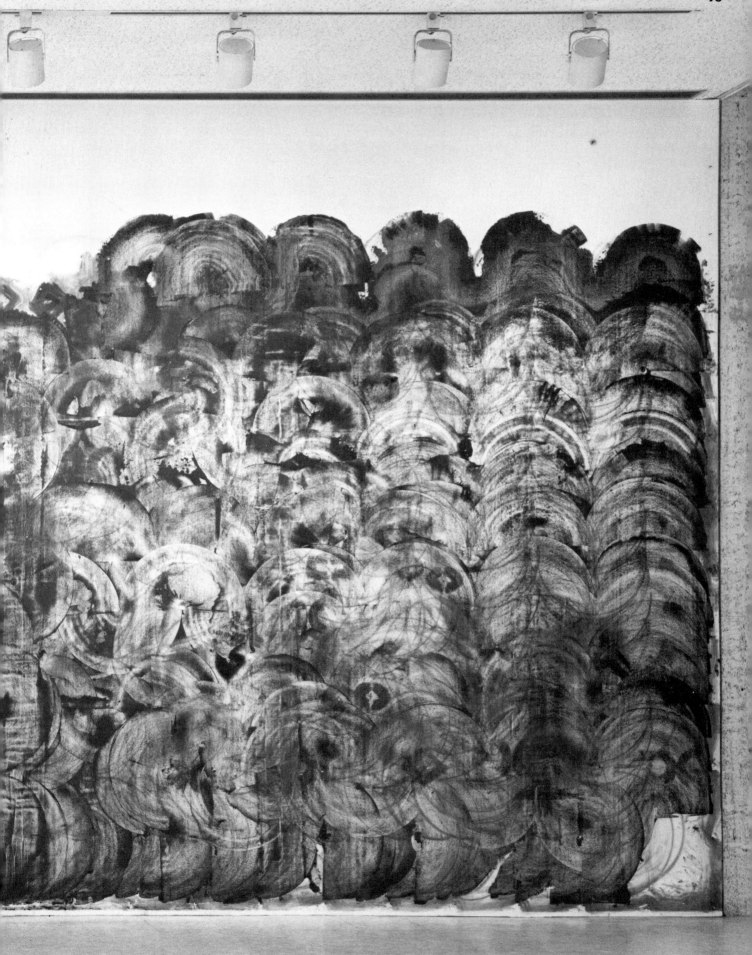

NOTES TO THE TEXT

1. St. Luke was the patron saint of painters.

2. The quotations in this paragraph are drawn from Erwin Panofsky, "Mannerism," *Idea: A Concept in Art Theory* (New York: Harper and Row, 1968), pp. 71-99. Originally published in German, 1924.

3. Lawrence Alloway, "Sol LeWitt: Modules, Walls, Books," *Artforum* (New York), April 1975, pp. 38-43. I am indebted to Mr. Alloway, who in this article first established a direct connection between LeWitt and Zuccari's sense of conceptual drawing. I had been exploring *disegno* and its relationship to recent drawing before the publication of the article, but Mr. Alloway's explicit juxtaposition of Zuccari and LeWitt was an important clarification of the direction in which my work on both the exhibition and this publication had been proceeding in terms of the entire period under discussion.

4. Ibid., p. 38.

5. Francisco de Hollanda, *Four Dialogues on Painting* (1549), quoted in Elizabeth Gilmore Holt, ed., *Literary Sources in Art History* (Princeton, N.J.: Princeton University Press, 1947), p. 218.

6. Some experts categorize much further. Rawson, for instance, lists six preparatory categories of drawing: calligraphic exercise, pattern types, record-of-fact drawings, diagrammatic summaries of information or doctrine, theoretical diagrams, copies; eight phases of drawing in the creation of a work of art: first thoughts or sketches, developments of parts of a design, studies "after nature," drawn-up designs, the cartoon, large-scale drawing as the basis for final work, underdrawing for subsequent painting, and the *modello.* He also posits two special categories: drawing as enhancement of an object and drawings for mechanical reproduction. Finally he lists drawings in their own right—or "emotionally autonomous" drawings. Philip Rawson, *Drawing* (London: Oxford University Press, 1969), pp. 283-316. It is also possible to categorize drawings according to subject types, e.g., nudes, portraits, landscapes, etc. Architectural drawings are in a separate, highly specialized category.

7. Vinigi L. Grottanelli, "Drawing," *Encyclopedia of World Art* (New York: McGraw-Hill, 1961), vol 4, p. 462.

8. Meyer Schapiro, "Nature of Abstract Art," *Marxist Quarterly,* January-May 1937, p. 82.

9. Quoted in Maurice Merleau-Ponty, "Cézanne's Doubt," trans. Sonia Brownell, *Art and Literature* (Lausanne), Spring 1965, p. 111.

10. From an interview with Marcel Duchamp by James Johnson Sweeney, "Eleven Europeans in America," *Museum of Modern Art Bulletin* (New York), vol. 13, nos. 4-5, 1946, p. 20.

11. Schapiro, "Nature of Abstract Art," p. 85.

12. Merleau-Ponty, "Cézanne's Doubt," p. 113.

13. Jacob Bean, "Georges Seurat: Portrait of Edmond-François Aman-Jean," *100 European Drawings from the Metropolitan Museum* (New York: The Metropolitan Museum, n.d.), no. 78, n.p.

14. Lucy R. Lippard, ed., *Surrealists on Art* (Englewood Cliffs, N.J.: Prentice-Hall, 1969), p. 2.

15. For further discussion of Beuys's drawing see Caroline Tisdall, "Of Fat, Honey, and the Rest," *Joseph Beuys: The Secret Block for a Secret Person in Ireland* (Oxford: The Museum of Modern Art of Oxford, 1974), catalog of the exhibition, n.p.

16. Unsigned introduction, *Joseph Beuys: The Secret Block* (see note 15).

17. Ibid.

18. Robert Pincus-Witten, "Cy Twombly," *Artforum* (New York), April 1974, pp. 60-64.

19. Quoted in Hugh Kenner, *A Homemade World* (New York: Knopf, 1975), pp. 180-81.

20. Ibid., pp. 177, 180.

21. Dorothy Seckler, "The Artist Speaks: Robert Rauschenberg," *Art in America* (New York), May-June 1966, p. 84.

22. Parts of this discussion follow notes provided by William S. Lieberman, Elaine L. Johnson, and Eila Kokkinen for the first exhibition of the Dante drawings, The Museum of Modern Art, 1965-66.

23. Quoted in Leo Steinberg, *Jasper Johns* (New York: Wittenborn, 1963), n.p.

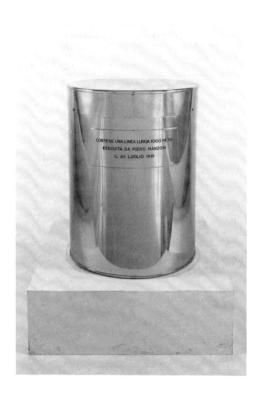

PIERO MANZONI. *LINE 1000 METERS LONG.* **1961. INK ON PAPER IN CHROME-PLATED METAL DRUM, 20 1/4 X 15 3/8" (51.4 X 39.1 CM). THE MUSEUM OF MODERN ART, NEW YORK, GIFT OF FRATELLI FABBRI EDITORI AND PURCHASE**

PIERO MANZONI was born in Soncino, Italy, in 1933. His early paintings, from 1951 to 1955, were mainly figurative. In 1956 he began to incorporate real objects in his paintings. Manzoni, in collaboration with other artists, published several manifestos, the first, "For the Discovery of a Zone of Images," in 1956. In 1957, after seeing the work of Yves Klein, he did his first *Achrome,* a gessoed canvas with scratched and cut surface. The Achrome series continued to occupy him until his death. By 1959 he was also producing his Sealed Lines and was exhibiting widely throughout Europe. He died February 6, 1963, in his Milan studio.

Bibliography:

Agnetti, Vincenzo. *Piero Manzoni.* Milan: Edizioni Vanni Scheiwiller, 1967.
Celant, Germano. *Piero Manzoni.* Catalog. Rome: Galleria Nazionale d'Arte Moderna, 1971.
Celant, Germano. *Piero Manzoni.* Turin, Italy: Sonnabend Press, 1972.
Celant, Germano. *Piero Manzoni: Paintings, Reliefs and Objects.* Catalog. London: The Tate Gallery, 1974.
Kultermann, Udo. *Manzoni.* Catalog. Eindhoven, the Netherlands: Stedelijk van Abbemuseum, 1969.

JAMES LEE BYARS. *UNTITLED OBJECT.* 1962-64. CRAYON ON JAPANESE HANDMADE FLAX PAPER, HINGED AND FOLDED; SHEET, 12 X 12" (30.5 X 30.5 CM); TOTAL COMPOSITION, ACCORDION-FOLDED, 210' 9" (65.1 M) LONG. THE MUSEUM OF MODERN ART, NEW YORK, GIVEN ANONYMOUSLY

JAMES LEE BYARS was born in 1932 in Detroit, Mich. His early education was received in Detroit public schools, and he attended Wayne State University in Detroit for three and a half years. Byars has lived and worked both in the U.S. and Japan. During the 1960s he staged several performances and street events, including an event featuring one of his folded-paper compositions in the temple of Shokukuji Monastery, Kyoto, Japan.

Bibliography:

Barnitz, Jacqueline. "Six One Word Plays," *Arts Magazine,* September 1968, pp. 17-19.

Byars, James Lee. (Statement), *Opus International,* January 1971, p. 34.

24. Merleau-Ponty, "Cézanne's Doubt," p. 113.

25. Ludwig Wittgenstein, *Tractatus Logico-Philosophicus* (London: Routledge & Kegan-Paul, 1972), pp. 7, 15-17. Originally published in German, 1921.

26. For a further discussion of Pop art and risk see Suzi Gablik, Introduction, in John Russell and Suzi Gablik, *Pop Art Redefined* (New York: Praeger, 1969), pp. 9-20.

27. John Coplans, "Talking with Roy Lichtenstein," *Artforum* (Los Angeles), May 1967; reprinted in John Coplans, ed., *Roy Lichtenstein* (New York: Praeger, 1972), pp. 86-91.

28. Diane Waldman, *Roy Lichtenstein: Drawings and Prints* (New York: Chelsea House, n.d.), p. 22.

29. Panofsky, *Idea: A Concept in Art History,* p. 4.

30. Ibid., p. 5.

31. Bruce Glaser, "Oldenburg, Lichtenstein, Warhol: A Discussion," broadcast on WBAI, New York, June 1964; published in *Artforum* (Los Angeles), February 1966; reprinted in Coplans, *Roy Lichtenstein,* pp. 55-66.

32. Claes Oldenburg, "The Baroque Style of Mr. Anonymous" (1968), printed in Barbara Rose, *Claes Oldenburg* (New York: The Museum of Modern Art, 1970), p. 194.

33. Rose, *Claes Oldenburg,* p. 163.

34. Oldenburg (1966), in Rose, op. cit., p. 193.

35. Oldenburg (1968), in Rose, op. cit., p. 194.

36. Oldenburg, unpublished notes, n.d.

37. Oldenburg (1968), in Rose, op. cit., p. 195.

38. The quotations in this paragraph are drawn from Bruce Glaser, "Questions to Stella and Judd," interview broadcast on WBAI, New York, February 1964; subsequently edited by Lucy R. Lippard and published in *Art News* (New York), September 1966; reprinted in Gregory Battcock, ed., *Minimal Art: A Critical Anthology* (New York: Dutton, 1968), pp. 148-64.

39. Donald Judd, "Specific Objects," *Contemporary Sculpture: Arts Yearbook 8* (New York: Art Digest, Inc., 1965), pp. 74-82; reprinted in Gerd de Vries, ed., *On Art* (Cologne: DuMont Schauberg, 1974), pp. 121-36.

40. Robert Morris, "Aligned with Nazca," *Artforum* (New York), October 1975, pp. 26-39.

41. Alloway, "Sol LeWitt: Modules, Walls, Books," p. 40.

42. John N. Chandler, "Tony Smith and Sol LeWitt: Mutations and Permutations," *Art International* (Lugano), September 1968, pp. 16-19.

43. Sol LeWitt, "Paragraphs on Conceptual Art," *Artforum* (New York), Summer 1967, pp. 79-83.

44. Alloway, "Sol LeWitt: Modules, Walls, Books," p. 38.

45. Ibid., p. 39.

46. Morris, "Aligned with Nazca," p. 33.

47. John N. Chandler, "The Last Word in Graphic Art," *Art International* (Lugano), November 1968, pp. 25-28.

48. Michel Leiris, "Conception and Reality in the Work of Raymond Roussel," trans. Kenneth Koch, *Art and Literature* (Lausanne), Summer 1964, pp. 27-39.

49. William M. Ivins, *Art and Geometry* (Cambridge, Mass.: Harvard University Press, 1946). Ivins was Curator of Prints at The Metropolitan Museum of Art, New York.

50. Dorothea Rockburne, unpublished notes, n.d.

51. Naum Gabo and Antoine Pevsner, *The Realistic Manifesto* (1920), reprinted in Stephen Bann, ed., *The Tradition of Constructivism* (New York: Viking Press, 1974), pp. 5-11.

52. Morris, "Aligned with Nazca," p. 39.

53. Saul Bellow, "A World Too Much with Us," *Critical Inquiry* (Chicago), Autumn 1975, pp. 1-9.

PHOTOGRAPHY CREDITS

Photographs not acknowledged in the following list have been kindly supplied by the owners or custodians of the works.

Allen Photographers, Inc., Las Vegas: 57 *bottom;* Rudolf Burckhardt, New York: 33, 34, 36; courtesy Centre National d'Art Moderne, Paris: 44, 45 *top and bottom,* 46 *top and bottom;* Geoffrey Clements, New York: 49, 60 *bottom;* Bevin Davies, New York: 75 *top;* courtesy Fourcade, Droll, Inc., New York: 88; Kate Keller, New York: 51, 62 *bottom,* 66 *top,* 72-73, 80 *top,* 82 *top and bottom,* 83 *top and bottom,* 94; Walter Klein, Düsseldorf: 18; Wolfgang Keseberg, Cologne: 59; Jochen Littkeman, Berlin: 21; courtesy Paul Maenz Gallery, Cologne: 80 *bottom left and bottom right;* Joseph Martin, New York: 29; Robert E. Mates, New York: 63 *top,* 66 *bottom,* 67 *top,* 85; James Mathews, New York: 50, 62 *top,* 75 *bottom,* 95; courtesy Betty Parsons Gallery, New York: 90 *bottom;* Eric Pollitzer, New York: 13, 23, 38, 42, 58, 64, 78 *top;* courtesy Princeton University Art Museum, Princeton: 92-93; Nathan Rabin, New York: 21, 39, 63 *bottom;* Walter Russell, New York: 8, 84, 89, 90 *top left and top right;* Nick Sheidy, New York: 31, 54 *top and bottom,* 55 *top and bottom;* Shunk-Kender, New York: 86; courtesy The Solomon R. Guggenheim Museum, New York: 79; Soichi Sunami, New York: 25, 27, 28, 69, 70; Charles Uht, New York: 32; courtesy Van Abbemuseum, Eindhoven: 58 *top,* 74, 78 *bottom;* Malcolm Varon, New York: 20, 47, 53 *top*